KU-181-948

Art Classics

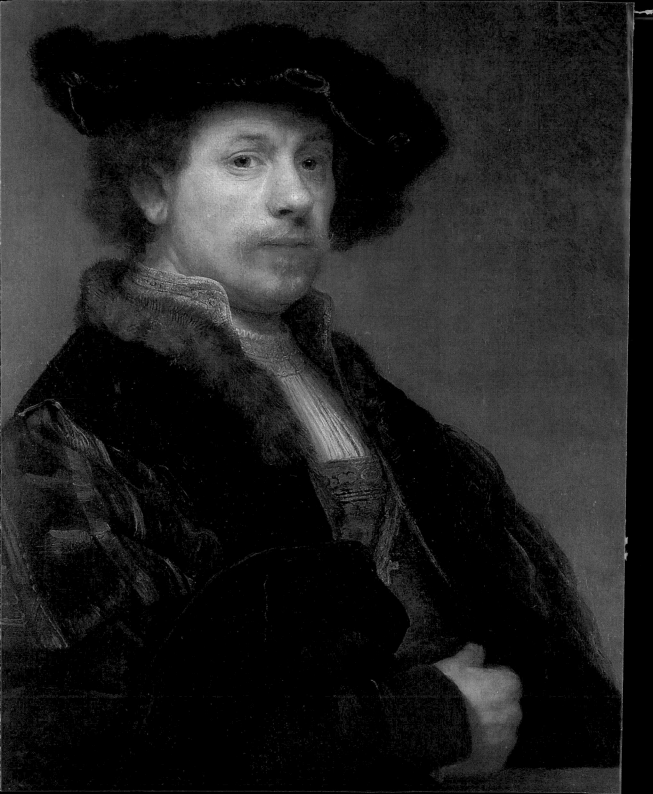

Art Classics

REMBRANDT

Preface by Giovanni Arpino

ART CLASSICS

REMBRANDT

First published in the United States
of America in 2006 by
Rizzoli International Publications, Inc.
300 Park Avenue South
New York, NY 10010
www.rizzoliusa.com

Originally published in Italian by
Rizzoli Libri Illustrati
© 2003 RCS Libri Spa, Milano
All rights reserved
www.rcslibri.it
First edition 2003
Rizzoli \ Skira – Corriere della Sera

All rights reserved.
No part of this publication may be
reproduced, stored in a retrieval
system, or transmitted in any form
or by any means, electronic,
mechanical, photocopying,
recording, or otherwise, without
prior consent of the publishers.

2005 2006 2007 2008 2009 /
10 9 8 7 6 5 4 3 2 1

Printed in China

ISBN-10: 0-8478-2908-1
ISBN-13: 978-0-8478-2908-8

Library of Congress Control
Number: 2006925808

Director of the series
Eileen Romano

Design
Marcello Francone

Editor (English edition)
Alta L. Price

Translation
Carol Lee Rathman
(Buysschaert&Malerba)

Editing and layout
Buysschaert&Malerba, Milan

Cover
The Shooting Company of Captain
Frans Banning Cocq
(The Night Watch)
(detail), 1642
Amsterdam, Rijksmuseum

Frontispiece
Self-Portrait with Embroidered Shirt
(detail), 1640
London, National Gallery

The publication of works owned by
the Soprintendenze has been made
possible by the Ministry for Cultural
Goods and Activities.

© Archivio Scala, Firenze, 2003

Contents

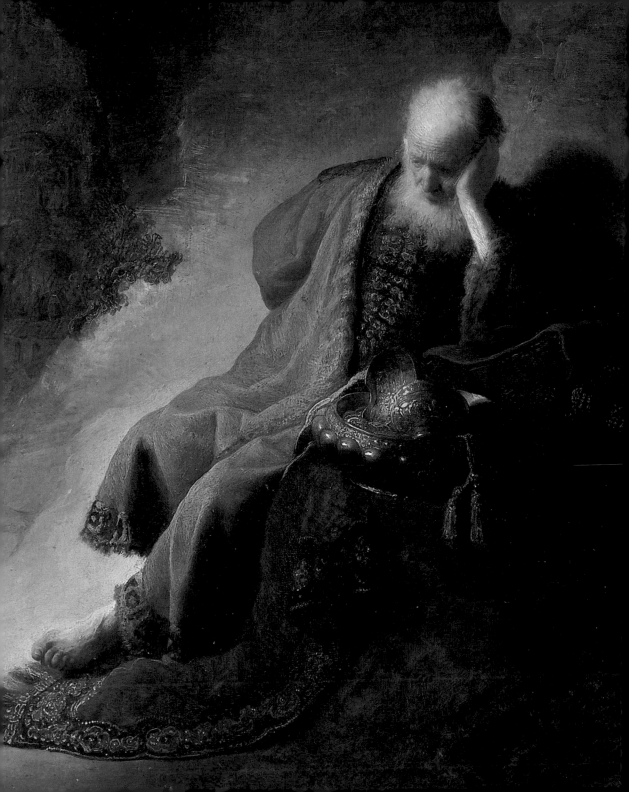

The Blood of a Pearl
Giovanni Arpino

Marcel Duchamp said that it is impossible, perhaps even blasphemous, to comment upon a work of art. Only the eyes and a certain mental approach can give us a correct position with regard to a canvas. Words are not only arbitrary, but also insolent and ridiculous, and they always risk overriding what the canvas or sculpture says. Words are not only arbitary, but also insolent and ridiculous, and they always risk overriding what the canvas or sculpture says. Words can betray.

Furthermore, who are we today, and by what measure can we evaluate the success of an old work of art? Exactly three centuries separate us from Rembrandt—an infinite distance.

We have lost our sense of measure, while a seventeenth-century European was truly the lord of the universe. The gap between Rembrandt and us is like the difference between his *Anatomy Lesson* of 1632 and a documentary film on open heart surgery; even the heart is different.

The seventeenth century was surely the last golden age. Immediately afterwards, the gold corroded and vanished, and history had to invent the luminaries. The seventeenth century is a great theater, the self-assuredness of a bellicose and satisfied continent called Europe. When Rembrandt died in 1669, Newton had broken up light, Molière had staged *Le Misanthrope*, and Milton had finished *Paradise Lost*. A huge curtain was about to fall on the pride and certainties of an Europe, even if its acts of domination would continue to delude for some time to come.

"He had a deep knowledge of human nature only to his credit—one of those geniuses so rare that they are called creative geniuses—and what is

Jeremiah Lamenting the Destruction of Jerusalem (detail), 1630 Amsterdam, Rijksmuseum

more, a fiery imagination." So wrote Joseph Baretti about Shakespeare, and we might say the same, looking at Rembrandt.

The cultural effort to approach Rembrandt may be useful, but it is not indispensable. He was born into a brilliant pictorial context, yet it was still doctrinaire: Dutch painters painted *veritas* and *vanitas* in perspectives of mirrors, meticulously obeying rich and satisfied patrons, respecting the magic boxes of the opulent interiors with checkered floors, the women's harmonious and sweet caps, hands perfectly poised over a spinet, and shadows divided between ceilings and doors, doorways and chairs, lamps and sword hilts and justicoats and velvets and silver. Rembrandt was born in the heart of this perfect geometry, and he could only share it with an immense pride in craftsmanship and obedience to trade secrets. He would have to invent not a stormy wind, but a sublime one able to upset this excessive harmony. And so he invented light not as color, but as a quality.

Rich and fat corporate supporters, plump yet evanescent women, rings and hens, swords and boots, fifes and scarves, profiles of individuals, and entire groups live in the pictures of seventeenth-century Holland. It is a noble art—but never truly daring; it offers a witness account of people, social classes, the powerful, proud communities, aware of their weight. But in Rembrandt, they return to being simple elements, the dice to be cast in a battle against fate. For this reason he was rich, then ruined, and later disdained by his own patrons, who feared they would not find respect for their features in the portraits. Moreover, he became a fierce and fanatic collector, with intrigues and quarrels over money that would earn him accusations and clashes even with loved ones. But he never betrayed himself, or yielded, or stopped; he was a master more of himself than to his pupils or imitators.

Rembrandt contemplates his figures with the gaze of a god who does not love them, but understands them; he does not judge them, but places them on a difficult stage. And he endows them with light, the better to call

attention to their earthly presence. Caravaggio was the Ulysses of this type of painting, but Rembrandt is an Aeneas, more refined and shrewder.

According to Caravaggio "A good painter is one who knows how to paint and imitate natural things well," and by now we know how much of an illusion this was, almost a verbal alibi, because from all "natural things," Caravaggio's genius chose the most diverse, difficult, and vexing, and then placed them in a revolutionary arrangement. Rembrandt does not even have to choose. He sees. His portraits do not concern people, but grandiose specks, splinters of an overheated, shadowy universe shaken up by perpetual motion and a deepset wanderlust.

Rembrandt adores detail: the toe of a shoe, a ring, an arquebusier's moustache, a creased collar, a leather belt, the studs of a helmet. However, only the details that interest him—which, therefore, become essential— like highlights to distribute on disintegrating forms. After all, this adoration never distracts him from the concept. It is the idea that dominates the painting, a concept of life and of the world that asserts, if anything, the value of the single object, which is absolutely perfect but never determinant. Not coincidentally, toward the end of his life, Rembrandt's light prevails, drowning out any element that cannot become protagonist of its own appearance.

In the very affluent Holland of his lifetime, home of merchants who had everything—gold, enamels, fabrics, carpets—he was a *master*. He treated his rivals and patrons with respect, but also indulged in moments of arrogance, and charged them high prices for his work. For *The Night Watch*, the members of the arquebusier militia chipped in for a sum total of sixteen hundred guilders, and Rembrandt tossed them into the darkness of the painting without yielding to the pressure and the flattery of those who desired a place in the front row, as every other group painter had always done to then. No amount guilders that could distract the master from his idea-painting.

Rembrandt makes apparent what is invisible, just as Shakespeare makes

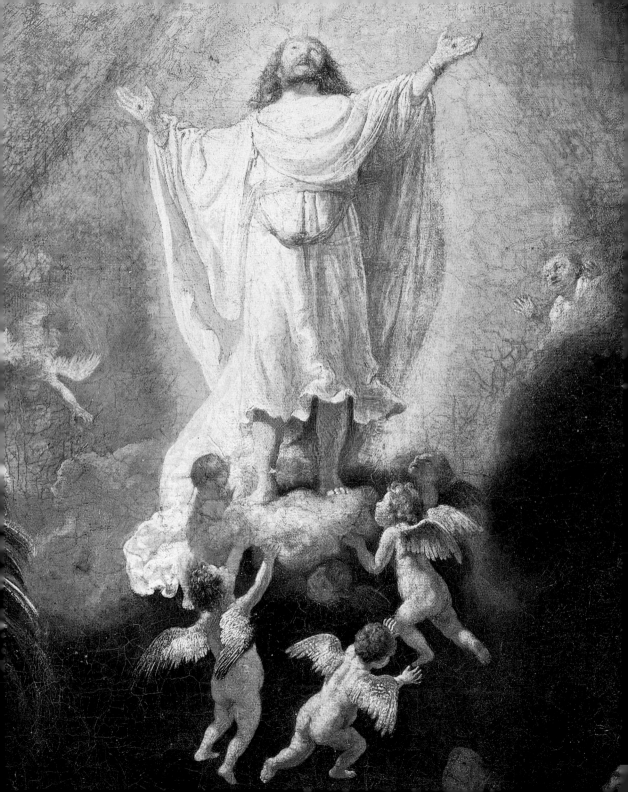

Ascension
(detail), 1632
Munich, Alte
Pinakothek

certain unreal situations seem logical. As only a dramatic genius can do, Rembrandt leads the observer by the hand to make everything seem true to life and most exemplary. Rembrandt invented light not to illuminate, but to render his world unapproachable. A nocturnal blood surrounds his saints, captains, self-portraits, Samsons, and old men, and it is the secret blood of things, a liquid born by alchemy, drawn from the foliage of trees, edges of clouds, minerals, fabrics, metals, the stage wings of the houses, unleashed from who knows which shells, pearls, or philosopher's stones. His figures look like creatures of this world, but they do not belong to it: they are ghosts, symbols, emblems, and symbols of men, women, soldiers and merchants who come out for a minute to show themselves among the gaps created by an imagination in tumult. One gets the impression that they have to suddenly return to the luminous darkness of the canvas, and disappear there forever. In a moment something will happen, and the ghosts of *The Night Watch* will be buried forever by a change in light, that hand will no longer be a new expression of the hand, but just a semblance that returns to its original darkness, and so what had at first been swords and plumed caps, drums and halberds, beards, goatees, and scarves will return to the dark, black cradle, since the divine apparition's visit has ended .

For this reason Rembrandt becomes mysterious again, like a pyramid or an esoteric formula, a megalithic monument whose meaning can be arrived at through wearisome cultural facts, but access to which is cluttered and jammed with mystery. Everything seems crystal clear, precise, orderly, and translatable; everything starts out showing shapely signs of civilization and taste. And everything, at a given moment, eludes the gaze, the calculations, and a definitive familiarity. It evaporates, depriving us of even the illusion of having understood.

Velázquez did not elude us, in those years when he was painting court dwarves, dogs, and Spanish infantas, but Rembrandt now does. Or perhaps we should say that it is he, Rembrandt, who does not want us. Velázquez

needs to be looked at; he lives to reveal himself, to give himself. He is a genius because he wanted to communicate with us, too. Rembrandt is a genius that did not think of communications at all; his place is not the museum, but the *sale d'armes* of a guild of his own times, or the town hall of his Amsterdam, whether they loved him or not, revered him or not. For Rembrandt, it is as if history did not exist, and looking at him, we doubt history itself as a system of consequences and logic. Velázquez was horrified by history and its protagonists, and this is apparent to us, it gets through to us and shocks us. Rembrandt invented his own dream by himself, where men and things of another world, of a lost measure, live as prisoners. The more his attention becomes calligraphic, the more he escapes behind the theatrical curtain of abstraction; the more the painting acquires a human movement, a human passion, the further it gets from us, helpless and spellbound before the overwhelming classical quality.

We can read the life of Rembrandt, spiced up with misery, blindness, intemperance, and egoism: but even his life separates us from his work. The more anecdotes we learn about Rembrandt, the further his art gets from us, as if wrapped in a sticky film that excludes us. *The Syndics of the Drapers' Guild* and *The Jewish Bride* live in themselves, they do not need viewers, or people crowding before them. They work in secret, with a very high level of independence, like a tree or a mirror worked over by time, or an angel of the night sky, indifferent to the human gaze and comment.

No, Time, thou shalt not boast that I do change:
Thy pyramids built up with newer might
To me are nothing novel, nothing strange;
They are but dressings of a former sight.
Our dates are brief, and therefore we admire
What thou dost foist upon us that is old;
And rather make them born to our desire...

Deposition from the Cross (detail), 1633 Munich, Alte Pinakothek

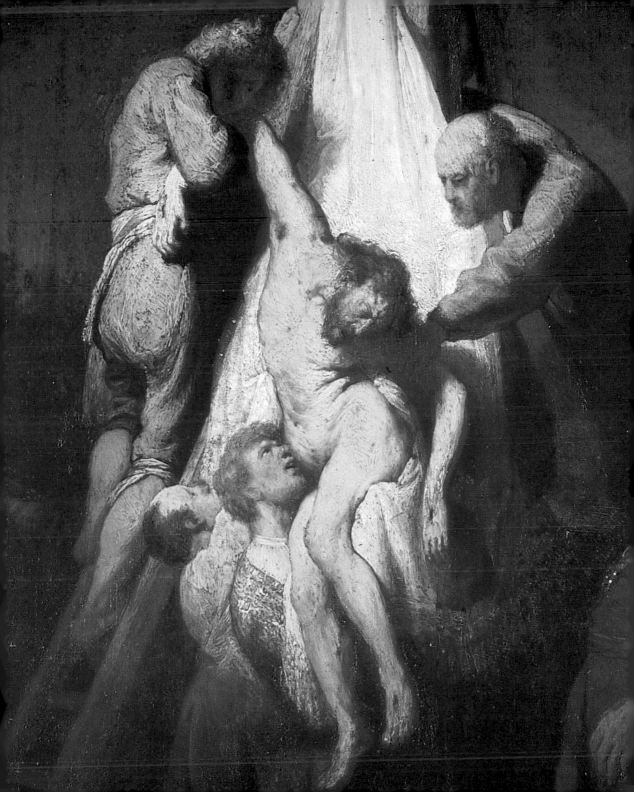

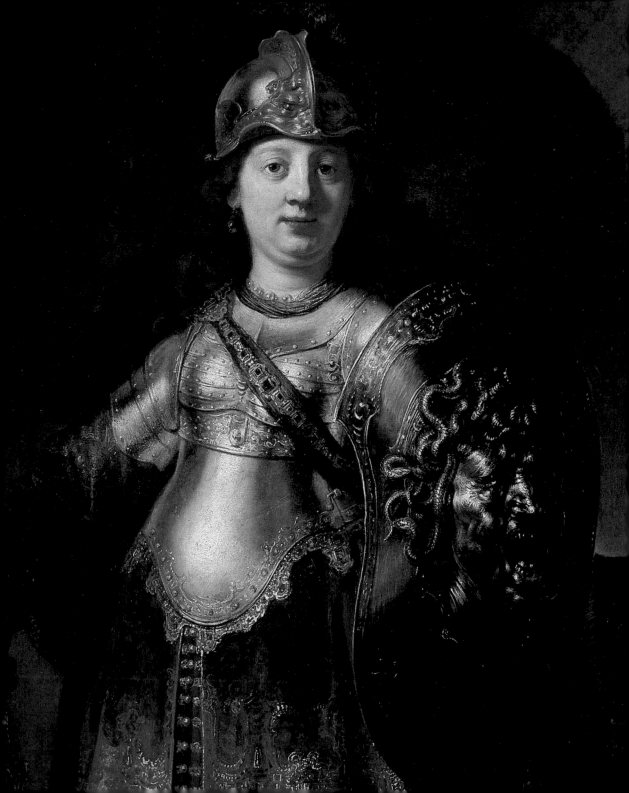

Bellona
(detail), 1633
New York, The
Metropolitan
Museum of Art

So Shakespeare wrote in a sonnet, and perhaps it is just this—the laughable pride that we must shed before going back to look, back to believing that we know how to look. When the classical quality irritates us, it is because, in some obscure way, we realize how lame, crippled, blind, and impotent we are. Our vengeful, agitated brain conjures up trenches and barriers to combat that classical quality. Nevertheless it continues to live on in itself, as indifferent to the criticism as it was to the praise.

It is among the marble and clouds of this classical quality that Rembrandt lives, an "ancient spectacle" that cannot be experienced again through new stagings. An excess of love can also betray, and not only the heart, but the eyes as well. Everything of Rembrandt's that does not reach us goes over our heads, the tiny target that we are does not have the structure or depth sufficient to contain and halt such a hurricane of rays.

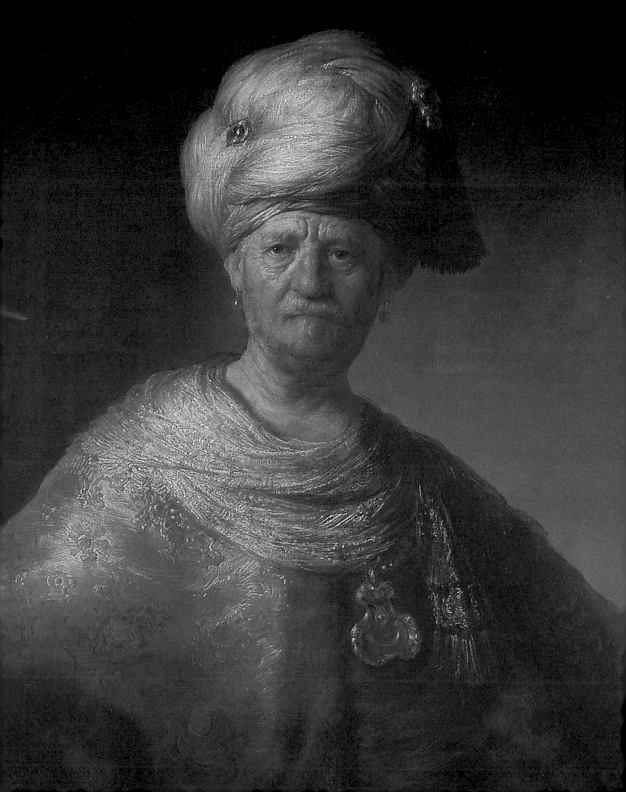

His Life and Art

Rembrandt Harmenszoon van Rijn (1606–1669) is the most celebrated Dutch painter of the golden age: there is a rich array of biographical data and a corpus of works that includes some four hundred paintings, nearly three hundred engravings, and a large number of drawings.

Rembrandt was born in Leiden on July 15, 1606, the penultimate of nine children. His father, Harmen Gerritszoon, owned a mill at the city gates, near the Rhine River; the family name derives from the name of the river, since "van Rijn" means literally "of the Rhine." Rembrandt's mother, Cornelia van Suydtbroeck, was a baker's daughter, and came from one of the city's patrician families. The painter's parents were well off, and the boy was provided with a first-rate education.

Unlike his siblings, who were encouraged to learn the trades, Rembrandt was sent to the prestigious Latin school. The date of his enrolment is not documented, but we can assume that it took place when he was seven years old, in 1613. The insti-

tute had been founded in 1600, and its activity focused on teaching the Latin language, supported by the reading of such classics as Cicero, Virgil, and Ovid; at the same time the pupils also studied Greek. Religion classes called for the study of the Bible and the Calvinist doctrine. When the classes were over, fourteen-year-old Rembrandt was enrolled in the philosophy department of the University of Leiden, which had an excellent reputation, especially in the fields of biblical philology the humanities.

According to the mayor, Jan Orlers, who wrote Rembrandt's first biography in a guide to Leiden in 1641, at the university the youth found "no pleasure or inclination, since his natural impulses turned exclusively to painting and drawing."

Rembrandt soon left his studies and went as an apprentice to the workshop of Jacob van Swanenburgh, from whom he learned the rudiments of painting. The reasons behind this choice are unknown, but it is clear that it widely diverges from his par-

page 16
The Noble Slave
(detail), 1632
New York, The Metropolitan
Museum of Art

ents' original ideas. Enrolment at the Latin school and university seemed to lead up to a career in law or public administration, and certainly was not necessary for practicing the trade of painter.

Jacob Isaacszoon van Swanenburgh was a painter in Leiden. He was Catholic, and specialized in scenes of hell and witchcraft inspired by the works of Bosch and Pieter Brueghel the Elder. At the start of the century he had spent several years in Italy, a common practice among artists at the time.Rembrandt stayed at van Swanenbrugh's workshop for three years, until 1623. The following year, he moved to Amsterdam for six months, as an apprentice in the shop of Pieter Pieterszoon Lastman, who became his true teacher.

Lastman was a successful painter of historical scenes: his paintings mostly illustrated episodes of the Old and New Testaments, as well as subjects drawn from myth and history. After an initial period of training in Holland, he traveled to Rome, sometime around 1603. There, he learned about late-mannerist painting and the Carraccis; he also saw the works of Caravaggio and Adam Elsheimer. Upon his return to Amsterdam in 1607, his style combined Nordic and Italian components: in his small, oil-painted panels, the figures and the landscape blend together in studied compositions. The scenes are richly constructed, with a great variety of details and characters; the chromatic range is full and the forms take on a cultural shape in the bright light. At the start of the twenties, Lastman took up handling his backgrounds in flat, sparse brushstrokes; his main interest was the story line, and this took precedence over the rendering of surfaces and the illusionistic effects of representation, popular characteristics of Dutch genre painting.

In his artistic career, Rembrandt followed this tendency of his teacher, taking it to completely original results; despite the refinement shown in some paintings, he re-

following pages
The Anatomy Lesson of Dr. Tulp
(detail), 1632
The Hague, Mauritshuis

nounced the meticulous art of description, preferring to handle the paint as a full-bodied material.

When his apprenticeship was over, Rembrandt returned to Leiden and started to paint independently. In analyses of his early works, scholars generally agree that the influence of van Swanenburgh was minor. It is obvious, on the other hand, that Lastman had a deep and lasting influence on Rembrandt's choice and handling of themes. For his first efforts, then, Rembrandt painted small paintings of religious subjects, and he took his inspiration from the formal codes of late Italian mannerism.

Returning to Leiden, the young painter soon joined forces with another artist two years his junior, Jan Lievens, who, having shown a precocious talent, had been sent off at around age ten to Amsterdam, to work in Lastman's atelier. When Lievens returned to Leiden, he was still a boy, and he continued practicing in his parents' home, painting historical subjects, still lifes, portraits, and genre scenes. Diverging widely from his master's style, he became interested in the Caravaggesques working in Utrecht. The most famous of these painters was Gerrit van Honthorst, also known as Gerardo delle Notti (Gerard of the Night Scenes), who returned to Holland around 1622 after a long sojourn in Rome. Taking up the formal innovations of both Caravaggio and Orazio Gentileschi, the artist painted genre scenes and biblical themes characterized by their elaborate lighting effects. Among the paintings Lievens did before Rembrandt's return to Leiden there are many interiors and night scenes brightened by artificial light, with a few life-sized and half-figure portraits.

The first years of Rembrandt's career were deeply marked by his collaboration with Lievens, which continued until 1631. In an initial phase, there seems to have been a straightforward exchange of ideas, especially concerning the subjectmatter; Rembrandt, however, continued to paint small pictures,

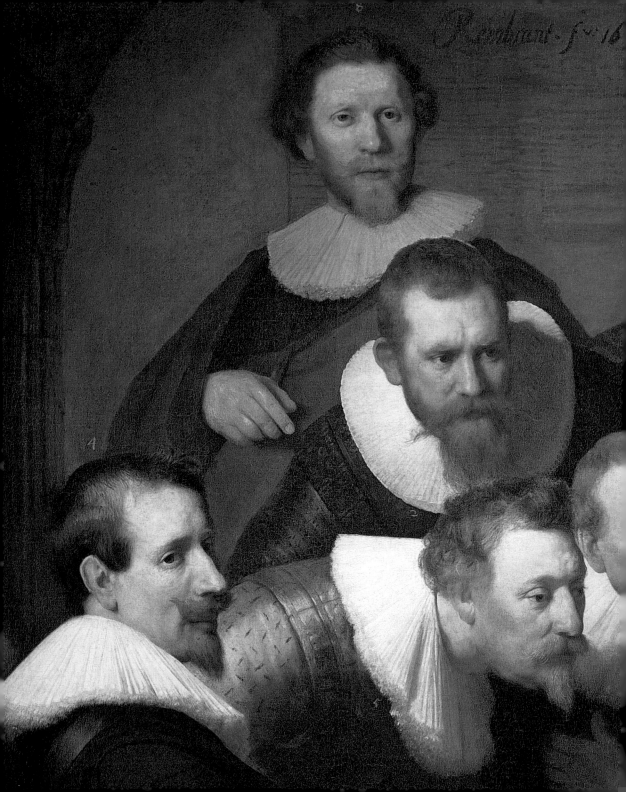

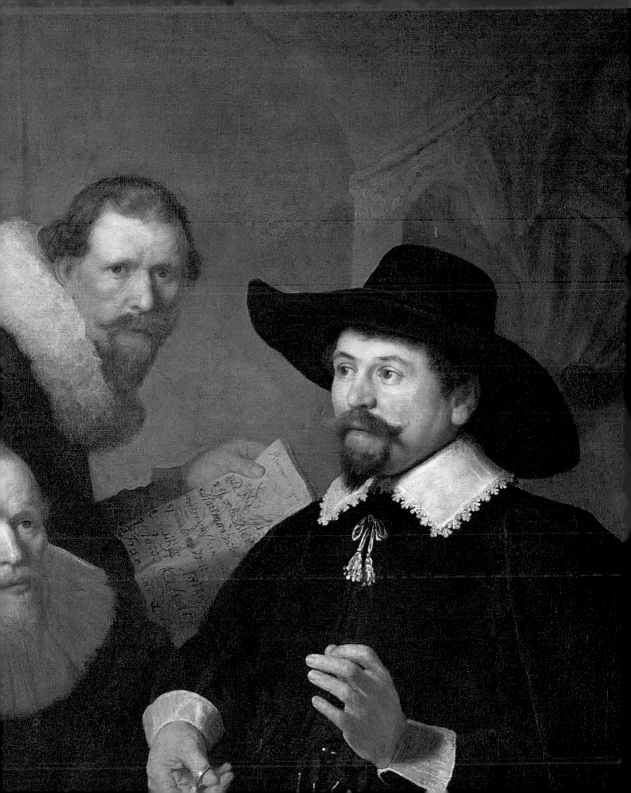

Portrait of Jan Hermanszoon Krul
(detail), 1633
Kassel, Staatliche Museen Kassel,
Gemäldegalerie Alte Meister

with full figures, while Lievens preferred half-figures in pictures of large dimensions.

Soon the two artists began to copy each other: they measured themselves up to one another, trying out the same subject. Studies of heads were very frequent, based on models dressed in historical or exotic costumes. In many of the faces Rembrandt painted in his youth, observers ingenuously thought they could recognize members of his family, in particular, his father and mother. It was believed that the artist had them dress up to raise them to the dignity of biblical figures. Rembrandt actually used these paintings in his repertory of models for historical paintings; from the studies of faces, expressions, and postures he took characteristic types to insert in other compositions. This habit proved to be quite useful, especially for artists who had a number of assistants in their shops: this was the case with Rubens, for example, who, with his paintings of soldiers, Africans, and old men, created an authentic catalogue for his apprentices to use. It may also be that, for Rembrandt, the studies of heads served the same function, since he started dedicating himself to them in 1628, just when his first apprentice entered the workshop, Gerrit Dou. Scholars have acknowledged that, in some cases, the artist had used his parents in costume as models.

Rembrandt's style slowly changed. Perhaps because of the influence of Lievens, and the Caravaggesques, he began to introduce into his own paintings refined nighttime effects and intense chiaroscuro highlights. What resulted were intimate atmosphere paintings, such as *Jeremiah Lamenting the Destruction of Jerusalem*, of 1630 (Amsterdam, Rijksmuseum). In this painting, the prophet sits sadly, in a dark place; in the background are red reflections of the fire in the city. The figure of the old man is surrounded by a luminous zone, in which the color gray goes transparent enough to let the yellow ground of the prepared panel show through.

Portrait of Saskia with Hat
(detail), *c.* 1633
Kassel, Staatliche Museen Kassel,
Gemäldegalerie Alte Meister

In 1628, Rembrandt and Lievens received an illustrious visitor at their studio. It was Costantijn Huygens, a diplomat and the secretary to the *stadhouder*, a man of letters and keen connoisseur of art. In his autobiography, written between 1629 and 1631, Huygens introduces some considerations about the painting of his time, and while on the subject he records some impressions he had during a visit with the two young painters. Admiring their innate talent, he recommends that they take the traditional grand tour of Italy for their education, which their teachers had also done in order to study classical antiquities and masterpieces of the Italian Renaissance and mannerism. The reply he got was quite significant: Rembrandt and Lievens felt they were too busy with their work to take time away from it. And, anyway, they said, so many Italian works made their way to Holland that a journey would almost be superfluous. Rembrandt's work confirms that, even if he never left the Netherlands, he was familiar with and understood classical art as well as that of the great Italian masters: in this respect, a fundamental role was played by the engraved copies widely in circulation on the Dutch market. Prints, including Flemish and German ones, made up a constant point of reference from which he could draw unique iconographic motifs, compositional solutions, and ideas for the choice and handling of subjects.

Huygens's pages also hold a lively portrait of Rembrandt: "[…] completely taken up with his work, he struggles to confine his ideas to a small painting, thus obtaining in a concise form the effects others seek in vain in their huge paintings." In comparing Rembrandt's work to that of Lievens, the refined connoisseur did not seem to have any doubt: "In the history paintings, as they are commonly called, Lievens is admirable, but it will not be easy for him to match Rembrandt's lively inventive force." This assessment is well aligned with the opinions of modern-day critics, and reflects what hap-

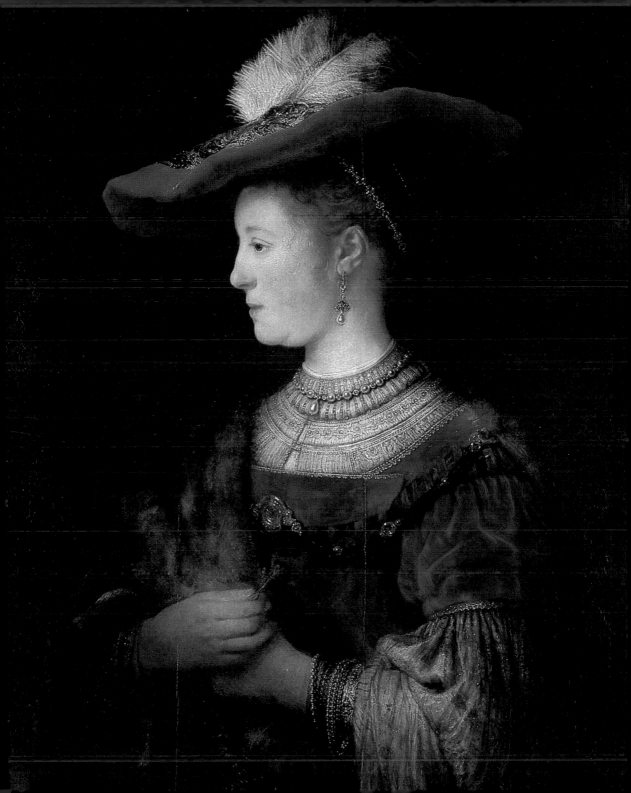

pened in the next phase of the collaboration between the two artists: Lievens started imitating Rembrandt, abandoning his life-sized figures for small scenes of history.

It is thought that sometime around 1625 Rembrandt began his experiments with etching, a technique that he continued to use until 1661. His incomparable importance in the history of this art owes much to the skill with which he combined mastery of technique, innovative capacity, and expressive refinement.

It has not been possible to establish who Rembrandt's etching teacher was, since none of the etchers that he could have known directly showed such a deep understanding of the characteristics of this medium. Of course, the artist could have referred to good examples, such as the Dutchman Hercules Seghers, the creator of highly original landscapes. Clearly, he was also familiar with the work of Jacques Callot, from whom he took cues for the countless images of beggars he etched over the course of his career. These are figures wrapped in torn, loose clothing; they are often bent with age and peer out from the deep isolation of the small plates Rembrandt used, against a neutral backdrop. The theme of the poorest classes was a pressing topic in Amsterdam, as, after the Thirty Years' War, poverty was a widespread problem. Rembrandt showed respect and compassion for the poor, to the point that an etching of 1630 shows him in beggar's guise.

For his etchings the artist preferred small formats, although on more than one occasion he proved that he was also able to make plates of significant size. The etching technique, liberated from the practical problems posed by the engraving burin, permitted him an extraordinary freedom of line: lines made with the etching needle could take on the most varied textures, like drawing. In the sixteen-forties Rembrandt started refining his etchings with the burin and drypoint, which allowed him to obtain

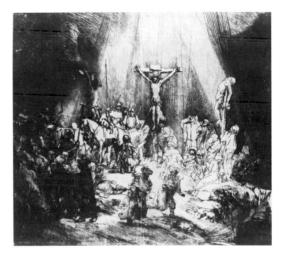

intense blacks and an impressive ink densi-
ty. He applied these expressive means to
the same subjects he took on in painting: sa-
cred scenes, studies of heads, self-portraits,
landscapes, portraits of family members,
and portraits done on commission.

Rembrandt often modified the plates
after the first impressions, creating different
states; most of the time, he worked on the
effects of light and shade, adding strokes in
areas that he wanted darker, or removing
them to obtain clarity. However, there are
some very interesting etchings in which he
made substantial changes between the var-
ious states. The most important example of
this is the etching *The Three Crosses*, dated
1653, of which five states are known. In the
three initial states, the artist offers a first
version of the theme of Christ's death: on
Golgotha, a blinding light brightens the
shadows and illuminates the scene of Christ
crucified between the two thieves. The com-
position bustles with figures, among whom
we can recognize the kneeling centurion,

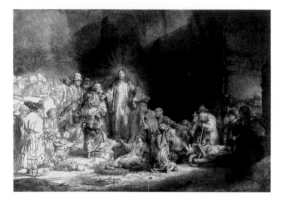

soldiers on horseback, holy women, and the disciples. In the next state, Rembrandt outlines a new version: the groups of onlookers have been deleted with heavy strokes of the burin, and the entire scene is filled with powerful shadows. Of the previous scene, only the figure of Christ remains, quite changed, along with that of the good thief. A new figure dominates from the center of the scene; it is a man on horseback, evidently inspired by one of Pisanello's medallions.

The acknowledged masterpiece of all Rembrandt's printed works is the etching widely known as *The Hundred-Guilder Print*, made between 1642 and 1649; the name derives from the extraordinary price it drew in Rembrandt's time. In this large-format print, the artist made a compendium of events from Chapter 19 in the Gospel of Matthew, organized around the central focus of the picture with Jesus healing the sick. The composition is divided into two areas handled quite differently: one pays minute attention to detail, and the other

seems unfinished. Around the luminous figure of Christ are various groups of people; the Pharisees discuss questions to put before Jesus in order to confuse him, the disciples listen to him, and a mother leads her son to him. In the background a camel emerges from the shadows, passing through a doorway; it is an allusion to Christ's words, "It is easier for a camel to go through a needle's eye than for a rich man to enter into the kingdom of God."

It was around 1628 that Rembrandt painted the first self-portrait known to us. In this panel, now at the Rijksmuseum in Amsterdam, the artist's features are wrapped in shade, because the light that shines in the background just grazes his cheek and his neck. The painter seems to be more interested in the light striking a face seen unexpectedly than in showing his own likeness.

Over the course of his life Rembrandt did a remarkable number of self-portraits: more than thirty paintings, twenty-six etchings, and twelve drawings. His pupils often copied these works, and among them some of his greatest masterpieces are reproduced. They reveal the effects of time on the artist's face and the marks of his personal fortune. In depicting himself, Rembrandt had different aims that gave rise to various kinds of self-portraits.

In self-portraits of the first period an interest in studying facial expression and physiognomy dominates: the figure seems subject to an energetic and sudden movement. In these works Rembrandt was not concerned with the thematic context, only the chiaroscuro and rendering of the states of mind: in this way he prepared material for his paintings of history, practicing before a mirror to capture the characters' emotions. In an etching of 1630 his mouth is open as if he were shouting, while in another he has the staring and surprised gaze of someone looking at an unexpected event; in a third, he laughs mockingly. This sort of self-portrait is a new appearance in the iconographic

Saskia Dressed as Flora
(detail), 1634
St. Petersburg, The State
Hermitage Museum

tradition: artists usually showed themselves as minor figures in historical scenes, as did Rembrandt on other occasions.

In the fertile period when he was working in Leiden, alongside the studies of expression, the first paintings in which Rembrandt meditated on his own role as artist appeared. The painting known as *The Artist in His Studio* dates from 1629: in a bare room, Rembrandt, wearing a smock and using the tools of his trade, observes from a distance a painting resting on an easel. The scene is described with a lively appreciation of realism, and there are various elements suggesting what the artist thought about painting and his own works. It seems possible to glimpse a celebration of the self-discipline involved in the job, summed up in the famous saying attributed to Apelles, "*Nulla dies sine linea.*" Furthermore, the painter's distance from the work could reflect the nature of artistic invention, which takes form in the artist's mind through contemplation. By showing himself at a certain distance from the painting, which is in full light, he illustrates his personal conviction that paintings require an overall vision, in the right light.

The many self-portraits in which Rembrandt appears in fanciful clothing or historical dress have also been interpreted in terms of self-awareness. It is thought that for these images the painter drew inspiration from the tradition of print portraits of famous artists in circulation from the sixteenth century on: here the unusual attire suggested the exceptional nature of the person depicted, and at times alluded to the stylistic peculiarities of his work. Sometime around 1629 Rembrandt portrayed himself in soldier's garb (The Hague, Mauritshuis), or as a Near-Eastern nobleman, with plumed cap, mantle, and gold chain (Boston, Isabella Stewart Gardner Museum). An original, full-figure self-portrait dates from 1631 (Paris, Musée du Petit Palais): the painter leans on a staff and wears an embroidered silk tunic, a mantle, and a turban. The solemnity of the

*Artemisia Receives the Ashes of
Mausolus (Sophonisba Receives
the Poison Cup)*
(detail), 1634
Madrid, Museo Nacional del Prado

by those in attendance, who compare it with what is illustrated in the book in the foreground. In traditional group portraits, the subjects were simply lined up in a paratactical way; Rembrandt instead made a painting of history, in which he showed an activity being carried out that involved all the figures depicted.

In 1632 Rembrandt painted a portrait of the Amsterdam merchant Marten Looten, and on that occasion he probably also sold the man the painting known as *The Noble Slav* (New York, The Metropolitan Museum of Art). The canvas shows an unknown Dutch model dressed in New-Eastern costume. In the sixteen-thirties there were countless other paintings of this kind, most of them indicated with such conventional names as *Bust of Man in Oriental Costume* (1633, Munich, Alte Pinakothek), *Biblical Figure in the Studio* (1634, Prague, Národní Galerie), and *Man in Historical Costume* (1637, Washington, National Gallery).

Compared with the studies of heads from the Leiden period, there are a few important innovations. First of all, the size of the paintings increases appreciably, and often the figures are shown life-sized. Furthermore, these paintings are more complex than the youthful studies from Duch daily life: often the figures are unidentified, although it is certain that Rembrandt intended to represent precise historical figures in his paintings, and most of them are biblical heroes. Clearly, then, these works cannot be considered simple studies from life for the purpose of history paintings; they make up a genre of their own, completely independent and particular.

In depicting the exotic costumes, headdresses, and jewelry of these figures, Rembrandt wished to suggest a distant, unknown world—the one described in the Old Testament. To do this, he turned to the Near East, an exotic and mysterious land, the destination of the trade voyages made by the East India Company, and the object of growing

attention. Rembrandt's Near-Eastern figures, who recur in his prints as well, had a powerful influence even outside of Holland, offering inspiration to the Italian artists Stefano della Bella and Il Grechetto.

While primarily occupied with portraits, Rembrandt continued through out the sixteen-thirties to paint scenes of history: sacred themes were joined by others from myth, and paintings of large dimensions, with life-sized figures, gradually predominated. In these paintings, Rembrandt used devices typical of baroque painting, going after the emotional involvement of the observer: the compositions are constructed in a dynamic way, and they are enlivened by strong contrasts of light and dark. The narrative characters are placed in high relief, and the artist takes particular care in rendering sentiments through gestures, actions, and expressions.

To this effect, he preferred to depict episodes with a strong impact: recognition, sudden occurrences, dramatic dialogues, and situations that arouse reactions of surprise, or even fear. In *The Rape of Proserpine* (Berlin, Staatliche Museen) the composition is constructed on the oblique line indicated by the direction of the horse, and the characters' gestures express all the violence and despair of the moment. *Belshazzar's Feast* (London, National Gallery), on the other hand, shows feelings of surprise and fear, where the sudden appearance of a miraculous inscription provokes an immediate reaction: everybody recoils in fright and the terrified king knocks over a cup. The theme of divine epiphany is also shared by two of the finest paintings of these years, *The Sacrifice of Isaac*, of 1635 and *Danae*, both in St. Petersburg.

Starting around 1635 Rembrandt became interested in landscape as well; he dedicated some paintings to this genre, and a significant number of drawings and etchings. In the graphic works, unlike in the paintings, critics have recognized life studies of actual places. The artist observed the

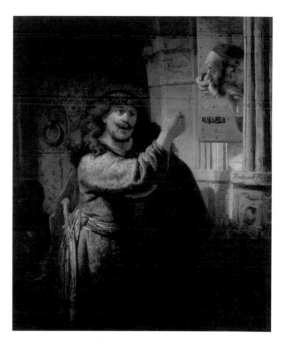

countryside around Amsterdam and faith-fully recorded the different effects of light at different times of year and day, inter-preting them in a lyrical, suggestive way.

In 1633, Rembrandt drew portrait of a young woman with a round face and sweet expression: the young lady wears a hat decorated with flowers, and leans pen-sively on a table. In the margin of the draw-ing, the painter wrote in solemn tones that it was a portrait of his bride when she was twenty-one years old. The girl was Saskia van Uylenburgh, cousin of the art dealer Hendrick van Uylenburgh, with whom Rem-brandt still lived; Saskia was from Frisia, and had moved to Amsterdam after the death of her parents. Her family was well-off, and her father had held a prestigious post as public functionary. The wedding was celebrated in 1634, and the young couple settled in van Uylenburgh's house.

Rembrandt often made portraits of Saskia, in both paintings and prints. In a

*Artemisia Receives the Ashes of
Mausolus (Sophonisba Receives the
Poison Cup)*
(detail), 1634
Madrid, Museo Nacional del Prado

small etching of 1636 he showed her at his side, as she also appears in the canvas traditionally known as *The Happy Couple* (Dresden, Gamäldegalerie Alte Meister). In most of the paintings in which Saskia's features can be recognized, she wears elegant costumes: in two different canvases of the mid-sixteen-thirties (now in St. Petersburg and London) she appears, for example, as Flora. In these cases, it is hard to say if Rembrandt wished to paint her portrait in costume, or, as with his parents in Leiden, he used his wife as a model for historical figure.

The records show that in 1634 Rembrandt was a member of the Amsterdam painters' guild. In his paintings, he replaced his monogram with the signature "Rembrandt" without his surname: this seems to indicate that he wished to compare himself with the great Italian masters known only by their first names, such as Leonardo, Raphael, Michelangelo, and Titian. In 1640, at the height of his career, Rembrandt portrayed

himself in the guise of a sixteenth-century nobleman; *Self-Portrait with Embroidered Shirt* (London, National Gallery) plays a fundamental role in defining his artistic personality. For this canvas, the artist took his inspiration from two Italian examples, the portrait by Titian known as *Portrait of a Man (Ludovico Ariosto)* and Raphael's *Baldassare Castiglione*; both works were in Amsterdam in those years, in the collection of one of Rembrandt's clients, Alfonso López. The portrait of Castiglione had been bought at an auction in 1639, and Rembrandt, who had attended, made a quick sketch of it, writing "Count Baldassarre di Castiglione by Raphel, sold for 3500 guilders." By copying the pose and the style of clothing from these models, the artist meant to emulate the great Italian masters, and declared his spiritual affinity with the world of Italian Renaissance culture and aristocracy, to which Ariosto and Castiglione belonged. He did the same in another self-portrait etched in 1639, very similar to the London canvas.

38

previous pages
The Sacrifice of Isaac
(detail), 1635
St. Petersburg, The State
Hermitage Museum

In these years, Rembrandt worked for the court of The Hague, painting for *stathouder* Frederick Henry, Prince of Orange, the first panels of the *Passion of Christ* cycle: the series was made up of seven paintings done between 1632 and 1646, and represents a unique circumstance in his oeuvre. The sources do not shed light on the commission, which probably started with the purchase of *The Deposition* in 1633, which the Prince then decided to pair with *The Raising of the Cross*. In a later phase, sometime around 1636, three more canvases were ordered from Rembrandt, and, finally, the last two, depicting episodes from Christ's childhood. The cycle was to be placed in the private chapel of the palace at The Hague; the long period it took to complete the series led to a certain stylistic discontinuity, discernible despite the uniformity of the overall compositional principles. It is possible that Constantijn Huygens contributed to the idea of the cycle and the iconographic program, orienting Rembrandt toward classical models suited as much to the subject as to the final goal of the paintings. Seven letters written by the artist to the *stadhouder*'s secretary contain fundamental details for the reconstruction of the economic issues connected with the prestigious endeavor, as well as interesting notes about Rembrandt's ideas and artistic aims. In one passage, for example, the painter recommends that a painting he had just sent be hung in full light; elsewhere, he excuses himself for the long period of execution, explaining that it was necessary to make "the movements [of the figures] more intense and natural." As for money, Rembrandt asked rather high prices for his works; as the negotiations proceeded, the artist betrayed a certain apprehension, and urged payment, declaring himself prepared to accept a lower figure than initially asked. His financial situation was rather precarious, since in 1639 he went into debt to buy a new house on the Breestraat, the prestigious street where van Uylenburgh lived.

following pages
Danae
(detail), 1636
St. Petersburg, The State
Hermitage Museum

Rembrandt moved his studio to this house, though before it had been in a warehouse unconnected to his home; the last floor of the building was adapted by means of partitions to create small but separate spaces for his pupils and assistants. He kept a real academy at Amsterdam, which the pupils paid to attend; when they had completed their course of study, they could proceed with their activity independently or become one of the master's direct collaborators. It is estimated that in the course of his lifetime, Rembrandt had over fifty apprentices, some of whom went on to become famous painters themselves: worthy of particular mention are Gerrit Dou, Ferdinand Bol, Govaert Flinck, Carel Fabritius, Nicolaes Maes, and Samuel van Hoogstraten, the author of a treatise that has provided much information about the workshop's activities. Training lasted about five years and started with the practice of drawing: pupils learned by copying other works, prints especially, and then they perfected the rendering of volumes by reproducing statues and plaster casts. Finally, they reached the point where they could draw from life, with a nude or clothed model, and the human figure was studied in movement and at rest. To perfect expressions, gestures, and poses, and to apply the fundamental compositional principles, Rembrandt used to stage small theatrical productions exclusively for the shop: the pupils filled the roles of both observer and actor, when they identified with a character to depict. The practice of observing an enactment, faithfully reproducing every element of it, contributed to establishing certain stylistic features of Rembrandt's art, such as the scenographic structure of the compositions, the qualities of light, the arrangement of the figures, and the expressive gestures typical of theatrical dialogue.

In a second phase, Rembrandt taught his pupils how to paint: in this case, too, instruction was based on copying exercises, and the models were for the most part tak-

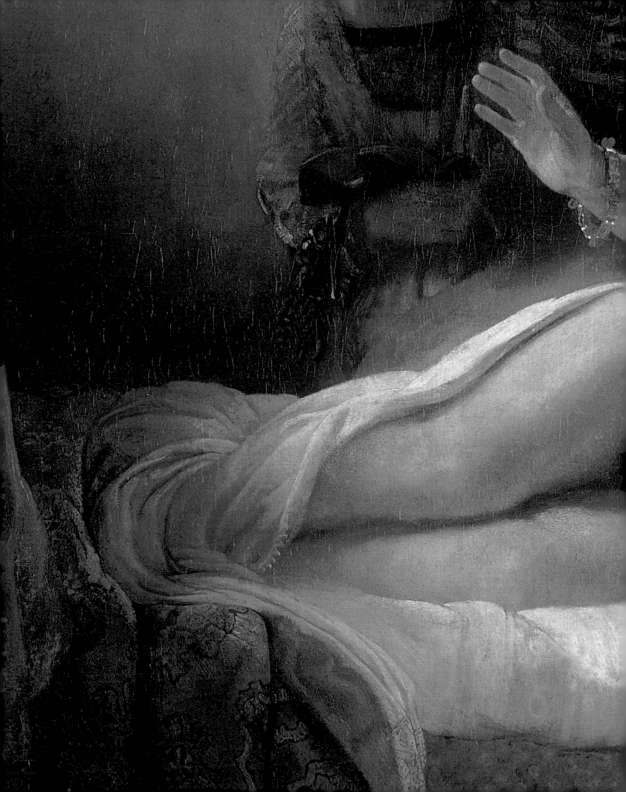

*Portrait of Cornelis Claeszoon
Anslo and His Wife Aaltje
Schouten* (detail), 1641
Berlin, Staatliche Museen zu
Berlin, Preußischer Kulturbesitz,
Gemäldegalerie

en from Rembrandt's own work. The young artists learned to imitate Rembrandt's style closely, to the point of being able to counterfeit it: for a painter in such demand on the market, this was a precious aid. We know of many paintings that show Rembrandt's signature, but which were done by his assistants; excluding the undisputed masterpieces, it is difficult to define the boundaries of his painted output. The attribution of his paintings has been under constant review; at the start of the twentieth century, over one thousand paintings were recognized as his, but through successive reductions, that number has dropped to around four hundred. Similarly his corpus of drawings is much disputed, and now stands at some fourteen hundred sheets.

His first period in Amsterdam concludes ideally in 1642, with the execution of his most famous painting, *The Night Watch* (Amsterdam, Rijkmuseum). The commission is not documented, although the painting should be seen as it relates to six others done by various artists in the period from 1638 to 1645 for the headquarters of the civic guard of Amsterdam. Govaert Flinck, Rembrandt's former pupil, also contributed to the project, painting two group portraits. Rembrandt's canvas is also a group portrait, large and original, showing the members of the arquebusier militia together with their captain, Frans Banning Cocq. The conventional title for the work was formulated toward the close of the eighteenth century, when the heavy layers of dark varnishes accumulated over the centuries gave rise to the idea that the artist had painted a night patrol. As he had already done with *The Anatomy Lesson of Dr. Tulp*, Rembrandt interpreted the group portrait as a historic scene. At the center, next to the captain, Lieutenant van Ruytenburgh gives the order to the company to march; preparations for the deployment begin. The artist orchestrated the composition according to dynamic forces; as in a theatrical scene, the figures emerge from a dark, undefined

The Shooting Company of Captain Frans Banning Cocq (The Night Watch) (detail), 1642
Amsterdam, Rijksmuseum

ground and move toward the observer, illuminated by light sources external to the picture itself. Rembrandt lingered insistently on the individual portraits, minutely describing their physiognomies, attire, the arms. Such fidelity to reality is, however, accompanied by a strong symbolic importance, since the painting can be interpreted as a celebration of the militia and its role in city life.

In the same year that he signed his masterpiece Rembrandt lost Saskia: her health had been badly undermined by a series of pregnancies starting in 1635 with the birth of a baby boy who died while still an infant. This was followed by two premature stillbirths, and finally a child was born in 1641, Titus, who lived to adulthood. It would appear that after his wife's death, Rembrandt retouched a portrait of her that he had started in 1633, now in Kassel. The painter added a peacock feather to Saskia's hat, and a fur wrap. According to some scholars, these two elements allude to the theme of *vanitas*, the brevity of all earthly things. The opulent costume worn by the woman could be seen in this light; in fact, a similar dress appears in an etching by one of Rembrandt's pupils, titled *The Time of Death*.

For Rembrandt 1642 was the start of a very difficult period, marked by intricate sentimental, legal, and financial affairs. In the same period, there is an appreciable reduction in his artistic activities, which scholars attribute to a variety of causes.

With the death of Saskia, Titus was entrusted to a nurse, Geertje Dircks, and a relationship soon developed between the woman and the painter, ending some years later with her departure. In 1647, Rembrandt hired a young governess, Hendrickje Stoffels, whose presence probably also contributed to Geertje's separation. Two years later, Geertje brought a lawsuit against Rembrandt for breaching a promise of marriage: in reparation the court awarded her a sum of two thousand guilders annually. In

48

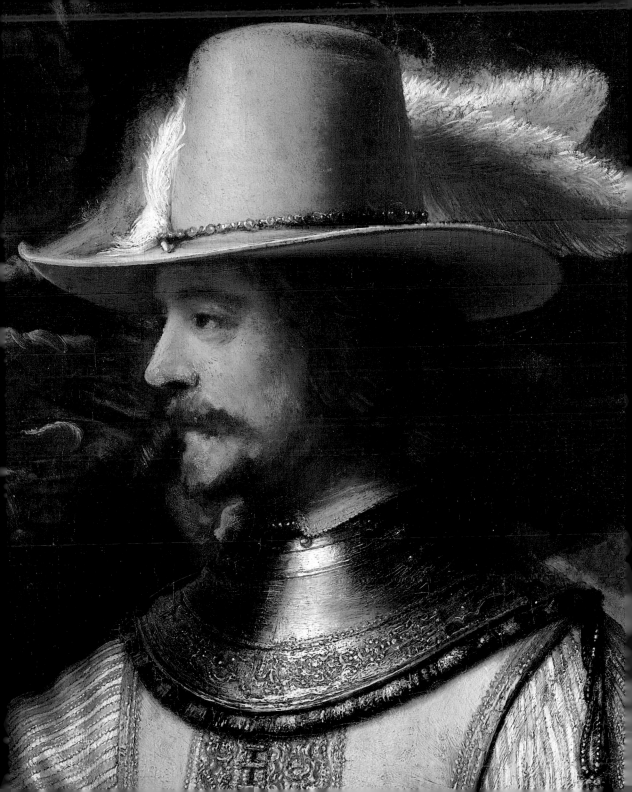

1650, Rembrandt had Geertje committed to the Gouda mental institution, declaring that she was not of sound mind. Meanwhile, Hendrickje had become his companion, and in 1654 she gave him a daughter, Cornelia. Rembrandt, however, could not remarry, as a clause in Saskia's will stipulated that in case of a second marriage, the painter would have lost his rights to the estate left to Titus. His financial situation was too precarious at that time, and it would have been impossible to face such a loss.

Over the years Rembrandt had contracted numerous debts, making purchases beyond his means; in 1650, two experts sent by creditors estimated the painter's assets in view of a possible declaration of bankruptcy. Three years later, he had still not settled his debt for the house bought in 1639, and the previous owner urged him to pay up. Rembrandt tried everything to avoid disaster, but in 1656 he was forced to acknowledge the gravity of the situation, and turned to the High Council of The

Hague to file bankruptcy. In this period the painter's income must have been very low: he was painting little, and his success with the city patrons had clearly waned.

We do not know the precise reasons for this. It was probably the result of a series of circumstances that critics have interpreted in many ways, stressing one aspect or another. There is no doubt that the dramatic events of those years deeply scarred Rembrandt, and distracted his attention from his painting. In the works of the second half of the 1640s, the spectacular lighting and flamboyant gestures made way for greater introspection. The small canvas entitled *Young Woman in Bed* (Edinburgh, National Gallery of Scotland), for example, seems a serene and intimate revisitation of the theme of Danae. As for his loss of favor among the city's patrons, critics have proposed various theories. Tradition has it that the unusual composition of *The Night Watch* alienated his admiring townsmen, but modern scholars reject this idea; it ap-

Jan Six,
1647
Drypoint, state III

pears that this painting has always aroused approval, and there is no record of disputes with the individuals portrayed. It has been suggested that patrons, perhaps discouraged by the lengthy waits for finished paintings, could now turn to the artist's many former pupils, who were able to imitate his style to perfection. Furthermore, artistic tastes in the patrician spheres seem to have taken a new direction, oriented more toward painting of a more classical style. Finally, it cannot be excluded that some people, for reasons of morality or social propriety, no longer wished to have anything to do with a man whose conduct stood in contrast with religious principles.

In 1654, Hendrickje was publicly tried before the church council, and was found guilty of engaging in an illicit relationship with the painter. It was perhaps as a consequence of this episode that Rembrandt lost one of his most important clients, the poet Jan Six. The two had probably met one another in the mid-1640s; the young gentleman

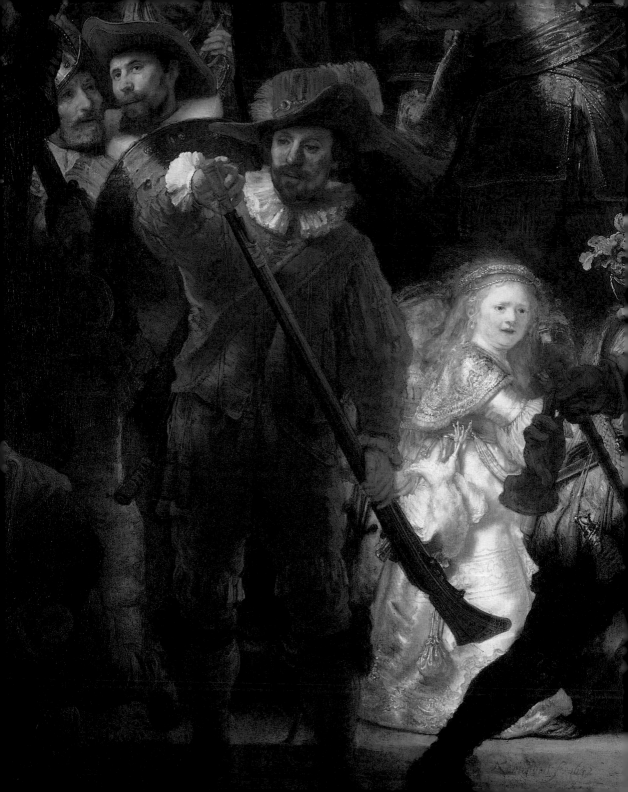

*The Shooting Company of Captain
Frans Banning Cocq (The Night
Watch)* (detail), 1642
Amsterdam, Rijksmuseum

from a rich family of fabric manufacturers, was a keen scholar and discerning collector. In 1647, Rembrandt portrayed him in a splendid etching where Six is shown in his study, surrounded by books and art objects, intently reading a manuscript.

The artist also made the frontispiece for the tragedy *Medea* for him, and two drawings for a private album. In 1654, the friendly relations between the painter and the refined collector had reached their peak, and Rembrandt portrayed him once again, in a painting of intense beauty. After this, it appears that the friendship was broken off. Six, meanwhile, had taken up a career in public office, and for this reason may have believed it unwise to keep his name associated with Rembrandt.

In 1656, after filing for bankruptcy, Rembrandt was summoned by the Chamber of Insolvent Estates and an inventory was drawn up of his possessions in view of their sale at auction. The document contains a list of paintings from the studio, furnishings, and household objects. This list also provides fundamental information about the encyclopedic collection that the artist had accumulated in the course of his career: some of the objects, however, had been sold at an auction the previous year organized by Rembrandt himself to meet the demands of his creditors.

The material described in the inventory should probably be seen in the context of an art trade that the painter, following van Uylenburgh's example, regularly conducted. In collecting works of art and various curiosities, furthermore, Rembrandt prepared for himself and his pupils a repertory of models as inspiration for copies and new inventions. However, above all, this collection was an expression of his prestige and the social status he had attained: it appeared, in fact, as a *Kunstkammer*, a collection of precious objects typical in late medieval northern European societies.

The section of natural objects (*natu-*

ralia) included stuffed animals, land and sea plants, corals and shells. Among the manmade articles (*artificialia*) were paintings, in particular, and drawings and etchings. Rembrandt owned paintings by Lastman and Rubens, as well as by such great masters of the past as Lucas Van Leyden and Raphael; some of these works may have been copies or imitations. The etchings were gathered in albums and subdivided by artist and school, and in part by subject, as they were often used in the workshop as iconographic sources. The sheets dated as far back as the fifteenth century, and bore the signatures of the greatest Italian and German artists. The listing also shows some twenty sculptures, both originals and casts; there were some busts of philosophers and a series of heads of Roman emperors. Rembrandt also collected costumes, arms, and works of art from the Near East.

At the time of the inventory, Rembrandt owned twenty-six portfolios of shop drawings, organized by subject like a genuine repertory. His drawing activity started and developed along with that of painting, and as the years went by the artist used different techniques, passing from charcoal to pen and ink and then watercolors. His pages are characterized by an extraordinary modernism of line, and sometime around the 1640s a stylistic evolution place: the exploration of painterly qualities replaced the previously forceful, dynamic, graphic line. Rembrandt rarely made preparatory sketches for paintings or etchings, even when working on very complex or large works. Instead, he used the drawing as a tool for study; he copied the work of others, and worked out problems of composition. He drew figures, faces, and small genre scenes from life.

In his papers there are many holy subjects and an equal number of figure studies. Also noteworthy are the landscapes of exceptional quality. The drawings had a fundamental role in the shop activity: the pupils trained by learning to draw, and in the initial

phase of study they copied from the master's pages. In some of the pupil's drawings, we even find Rembrandt's corrections and annotations, bearing witness to the didactic value that the artist attributed to this technique. When the inventory was drawn up, Rembrandt's assets were put up for auction and sold in various sessions between 1657 and 1658; the excessive supply probably caused the prices to drop, and the sum obtained was scant compared to expectations.

In 1652, Italian nobleman Antonio Ruffo di Calabria asked Rembrandt to make a half-length figure of a philosopher; the gentleman had an important art collection in his Messina palace, including precious objects, prints, drawings, and paintings by such famous baroque artists as Guercino, Guido Reni, and Van Dyck. Two years later, the artist sent him the canvas *Aristotle with a Bust of Homer* (New York, The Metropolitan Museum of Art), which met with full approval of the buyer. The consequent request of two more works as pendants to the first gave rise, after a complicated series of events, to *Alexander the Great* and *Homer*, done between 1661 and 1664. The small cycle illustrated the greatest philosopher, greatest poet, and greatest military leader of antiquity. A series of letters from Ruffo, and the Italian translations of the painter's replies, shed light on the unfolding of events. In 1661, the patron paid Rembrandt for *Alexander the Great*; the following year, however, having realized that it was painted on a badly patched canvas, he stated that it was worth only half the price. He added, moreover, that *Homer*, which had meanwhile arrived in Messina, had been painted in a hurry and sloppily, and that it had not been left to dry; for this reason, he was returning it to the painter.

In response to the criticism of *Alexander*, Rembrandt answered that the picture was painted well, and it would therefore be sufficient to hang it in the right light so that the seams did not show through; rather than accept the restitution or the depreciation of

the work, he declared himself prepared to paint a second canvas with the same subject. The successive developments in the affair are not known, and even the identification of the painting that was the object of these negotiations is not unanimous. There is one painting presumably of *Alexander the Great* now in Glasgow, and another at the Museu Calouste Gulbenkian, in Lisbon, which could be the second version. As for *Homer*, it has come down to our times in a fragmentary state, half-destroyed by an eighteenth-century fire. In representing the old, blind poet dictating his verses to a scribe, Rembrandt painted broad color fields with a rough surface, working in wide, evident brushstrokes. This handling probably aroused in the buyer the impression that the work was incomplete. In 1660 Ruffo also asked Guercino to make a painting to accompany the portrait of Aristotle; from an exchange of letters, we know the details of the commission and, especially, Guercino's expressions of admiration for Rembrandt's art.

Another important commission came in 1656, from the surgical guild of Amsterdam, which requested a group portrait of its most illustrious members: the painting was to be hung in the city's anatomical theater, already the home of *The Anatomy Lesson of Dr. Tulp*, signed by the artist in 1632. *The Anatomy Lesson of Dr. Deyman* has come down to us in damaged form; a fire in 1723 destroyed much of the canvas, almost completely obliterating the figure of the protagonist. The most significant element of the composition is the position of the cadaver, frontal to the observer; the foreshortening; the table, and the detail of the feet in the foreground are, according to many scholars, a citation of Andrea Mantegna's *Dead Christ*.

In the 1650s Rembrandt's style underwent a significant evolution. His figures became monumental, and nearly life-sized; they are constructed in parallel plains frontal to the observer, and this imbues the paintings with a classical sense of severity. This

is evident in *Bathsheba with the Letter from King David* (1654, Paris, Musée du Louvre): the majestic quality and statuesque look of the figure are common to many paintings of the period, starting with *Aristotle*. In depicting the biblical story of Bathsheba at her bath, Rembrandt eliminated all the extraneous narrative details called for by iconographic tradition: the woman's absorbed gaze foreshadows the later development of the story, which depends solely upon her choice.

The reduction of narrative motifs, which has led critics to talk of decontextualization, is even more evident in *Moses with the Tablets of the Law* now in Berlin: the scene is limited to just the figure of the protagonist, so that it becomes difficult to understand which episode it refers to.

Rembrandt's pictorial technique evolved toward extraordinarily modern effects. Having completely abandoned the glossy portrait surfaces of the 1630s, the painter deepened his experiments, taking his inspiration from examples by Frans Hals and the late works of Titian. He applied the paint in broad strokes, often spreading it with his fingers: thus the edges of the figures blurred, and the forms became vague.

In *The Slaughtered Ox*, of 1655, the paint is thick and textured, and the uneven handling of the painted surface suggests the very quality of meat, which the light strikes projecting real shadows; thick red enamels that seem to drip down the panel render the idea of clotted blood. For these features of expressive realism, *The Slaughtered Ox* has been taken up and copied by such modern painters as Eugène Delacroix and Chaïm Soutine.

In 1658 Rembrandt's house was sold to pay off creditors, since the auctioning of his collection had not yielded sufficient funds. The painter had to move, and he settled into a working-class district. Since a painters' guild regulation prohibited whoever had declared bankruptcy from con-

ducting any commercial activity, in 1660
Hendrickje and Titus founded a company,
declaring that they had hired Rembrandt as
employee. In 1660 he received a commis-
sion to paint *The Conspiracy of Julius Civilis*
as part of a project for the decoration of the
Amsterdam town hall, to which a number of
artists contributed. At first, the work had
been entrusted to the most celebrated
painter of the moment, Govaert Flinck, but
upon his death it became necessary to find
replacements. Rembrandt painted a work of
significant size (over 5 x 5 meters), which two
years later appears to have already been
mounted in its place.

Later, however, the buyers rejected it,
and returned it to the painter. The reasons
for this refusal are un- known. According to
some scholars, it was because the artist had
depicted the Dutch hero Julius Civilis as a
one-eyed old man, breaking the rules of deco-
rum. The leader of the Batavians was, in fact,
blind in one eye, but the other painters in-
volved in the town hall project had been

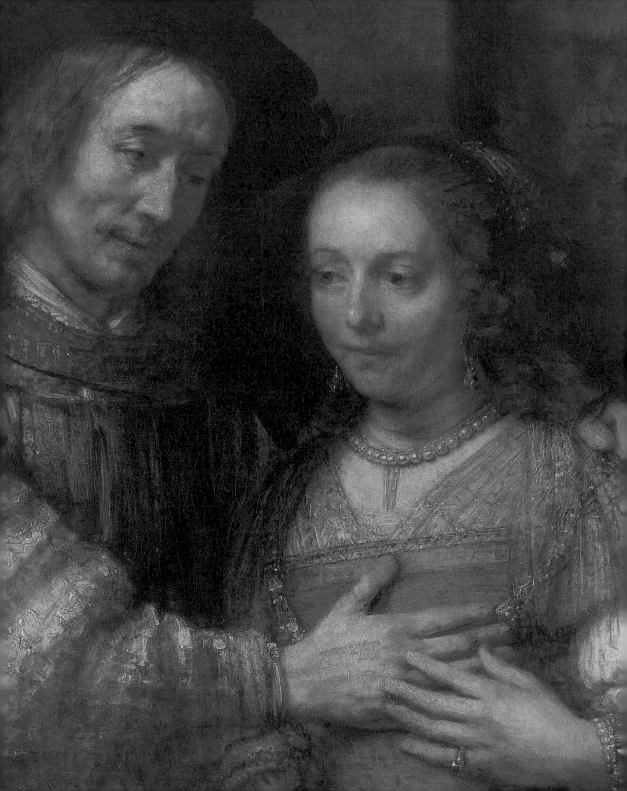

Isaac and Rebecca
(The Jewish Bride)
(detail), *c.* 1666
Amsterdam, Rijksmuseum

careful to show him in profile, and not face on, as Rembrandt had done. It may also be that the buyers' disapproval arose from aesthetic considerations: the figures on the canvas were reduced to synthetic forms, barely sketched out, and the color was applied in broad, practically monochrome fields; the pigments were smeared in thick, plastic impastos, and the overall impression was of an unfinished work.

The last public commission came in 1662 from the weavers' guild, for whom Rembrandt painted *The Syndics of the Drapers' Guild* (Amsterdam, Rijksmuseum). In 1667 he welcomed Cosimo III de' Medici to his studio, who almost certainly purchased works from him, perhaps drawings or etchings, perhaps one of the three paintings by Rembrandt today at the Uffizi.

In the paintings of his final years, experiments in technique seem to have prevailed in his approach to painting *The Jewish Bride* and *Family Portrait* are enigmatic and suggestive works in which the artist seems to renounce figurativism and realism. Color dominates everything, reduced to just a few shades and distributed on the canvases in rich, dense brushstrokes, blended unevenly, and applied in relief so as to make use of the light and project real shadows on the surface. In *The Return of the Prodigal Son*, Rembrandt leaves us a lyrical representation of the theme of pardon: the imploring son buries himself in the arms of his father, who clasps the young man's shoulders with a gesture of tenderness and pity. The youth wears worn-out clothes, torn and full of holes, and his blistered feet poke out from worn sandals. Using strong colors, the painter enclosed the two in a single, harmonious form and emotional embrace.

In the last years of his life Rembrandt suffered new bereavements: in 1663, Hendrickje died, and in 1668, Titus. In 1669, the painter stood as godfather to Titia, the girl born of the marriage of Titus and Magdalena Van Loo. That same year, on October 4, Rembrandt died at the age of sixty-three.

The Return of the Prodigal Son,
(detail), *c.* 1666
St. Petersburg, The State
Hermitage Museum

On the occasion of the third centenary of Rembrandt's death, the German art historian Horst Gerson, expert in the master's art, cast doubt on whether it was possible to ever know everything about the artist. This declaration of scientific relativism arrived after three centuries had passed, during which the artist's personality and work had been studied and analyzed from countless vantage points. The changing of the times and of aesthetic categories gave rise to the most diverse readings, occasionally even contrasting ones. Art historians, however, did not renounce the idea of elaborating a coherent vision of Rembrandt: the Rembrandt Research Project, founded in 1969, is a group of Dutch scholars who propose to investigate the master's entire opera with the help of modern technology.

The commonly held image of Rembrandt today is based on ideas of him in large part already in circulation in his own time, expressed by his contemporaries; he is still thought of today as a "heretic of art," the inventor of a completely personal style of painting founded on light, the dramatic expression of feelings, and the faithful rendering of natural phenomena.

In novels, as well as theatrical and cinematographic works, particular emphasis has been given to a few elements of his story and personality that were a decisive influence in his work: his middleclass origins, Protestant faith, the dramatic events that marked his adult years, and his original, non-conformist temperament.

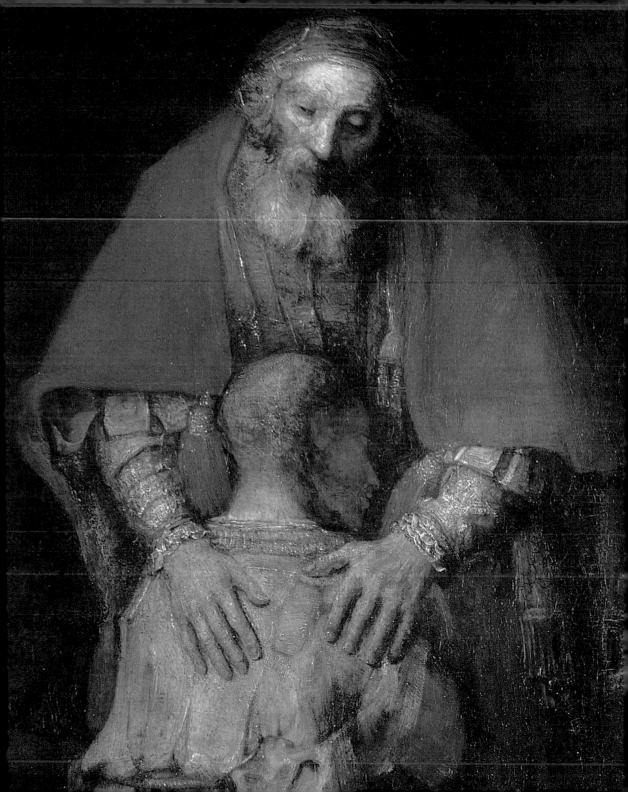

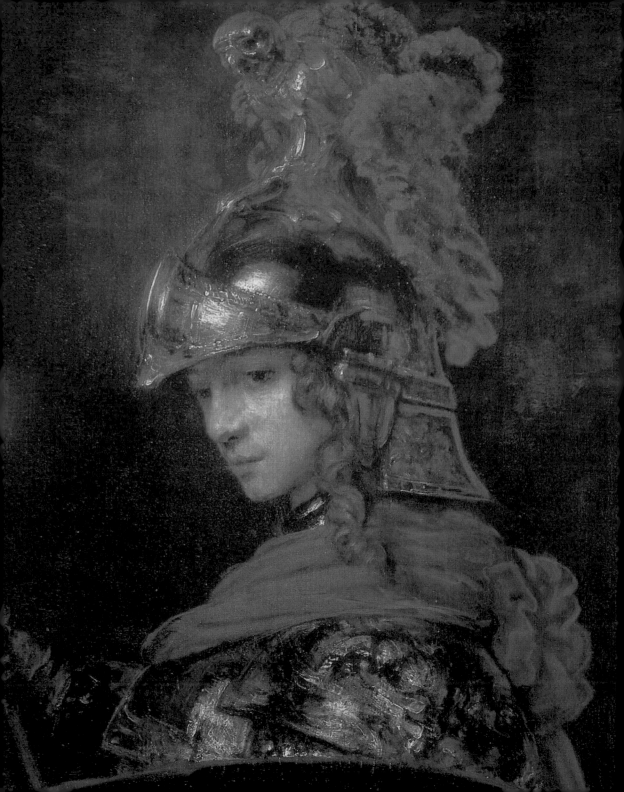

The Masterpieces

Alexander the Great
(detail), *c.* 1655
Lisbon, Museu Calouste
Gulbenkian

Music Concert in Costume

1626
Oil on panel, 63.4 × 47.6 cm
Amsterdam, Rijksmuseum
Signed and dated "RH. 1(6)26"

This youthful work of Rembrandt's turned up on the antiques market in the twentieth century. Although the subject is a departure from Rembrandt's preferred ones, and the style is unusual, attribution to him is generally accepted.

The painting shows a group made up of three musicians and an old woman listening with a pensive look; the figures are dressed in fantasy-inspired clothes, and the scene is set in a domestic interior. In the foreground a pile of books and a lute create a still life passage. The subject of the work invites comparison with the genre painting of the Utrecht Caravaggesques, which often showed music concerts and musicians playing. However, Rembrandt differs from these models by introducing elements from scenes of history; his figures are shown in full figure, and their costumes are like those of the biblical figures his partner Lievens painted. As for the composition in the foreground, it, too, is inspired by a genre that was popular in Leiden at the time, the still life theme of *vanitas*. In paintings of this sort, the illustration of beautiful, precious objects alluded to the brevity of life and earthly goods.

It is possible that there is a symbolic meaning underlying Rembrandt's painting, to which the attitude of the old woman seems to allude; her figure, in contrast with that of the young seated woman, confirms the concept of the "vanity of vanities". The painting shown in the background has been recognized as the biblical scene of Lot's flight from Sodom, an episode also associated with the fleeting nature of material things. According to some studies, the faces of the musicians and the old woman are portraits of Jan Lievens, Rembrandt, and his mother.

Self-Portrait with Unkempt Hair

c. 1628

Oil on panel, 22.6 × 18.7 cm

Amsterdam, Rijksmuseum

Rembrandt's earliest known self-portrait shows a few outstanding characteristics that shed light on its probable meaning. In the panel, the artist's features are cloaked in shade, as the light that illuminates the background barely grazes the back of his neck and his cheek; as for his clothing, a white collar is just summarily described. The painter's aim seems not so much to depict his own likeness as to study how the light strikes a face, as if taken by surprise. We must therefore assume that this self-portrait was useful to Rembrandt for his work as a history painter, since it is often possible to recognize his features in the minor figures appearing in his later works.

The nature of the lighting demonstrates the artist's interest in the experiments of the Utrecht Caravaggesques (including Honthorst, ter Bruggen, and Baburen); this is even more explicit in the *Parable of the Rich Old Man* of 1627. The paint is laid on thickly and scratched with the tip of the brush so deeply as to expose the prepared ground. Similar handling can be found in other youthful works, where the neutral ground, barely described by the light, also appears.

In 1632, Rembrandt probably took this *Self-Portrait* to Amsterdam. We also know of a copy painted by an assistant or pupil (in Kassel, believed by many to be the original), and a printed reproduction of 1634, the work of Jan Georg van Vliet.

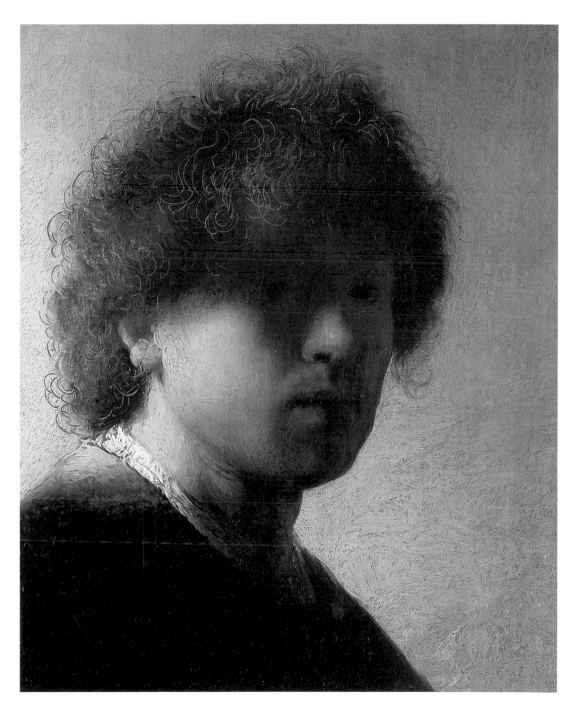

69

The Painter in His Studio

c. 1629
Oil on panel, 25.1 × 31.9 cm
Boston, Museum of Fine Arts

While the iconography of this painting is easy to interpret, it has nevertheless aroused discussions and comparisons among scholars about a wide range of issues. In this panel a bare room is depicted, with poorly plastered walls and a wooden floor; against the rear wall of the room stands a painter, with the smock and tools of his trade, observing from a distance a painting positioned on an easel. The scene is described with a lively realism, as attested by the depiction of the door and the cracked plaster around it, and especially the faithful replication of the workshop setting with palettes hung on the wall, the grindstone for pigments, and the table with bottles and crockery. The room is in full light, but the painter's face is not perfectly visible. Hence the doubt whether it really is a self-portrait or not; according to some scholars, the model could in fact be Gerrit Dou, Rembrandt's pupil beginning in 1628.

In the decision to depict the painter at a certain distance from the painting, which stands in full light, we can see the intent to illustrate the precepts Rembrandt expressed elsewhere, according to which paintings should be seen in an overall vision, and in the right light. The scene could also be a rendering of the self-discipline required of the artistic calling, practiced by Rembrandt and summed up in the famous saying attributed to Apelles, "*Nulla dies sine linea.*" Finally, the painter's detachment from the work could reflect the nature of artistic invention, which takes shape in the mind of the creator through contemplation.

The work, which differs from the foregoing tradition of portraits of artists at work, refers to the final phase of the Leiden period; some scholars doubt the attribution to Rembrandt, favoring instead an ascription to Gerrit Dou.

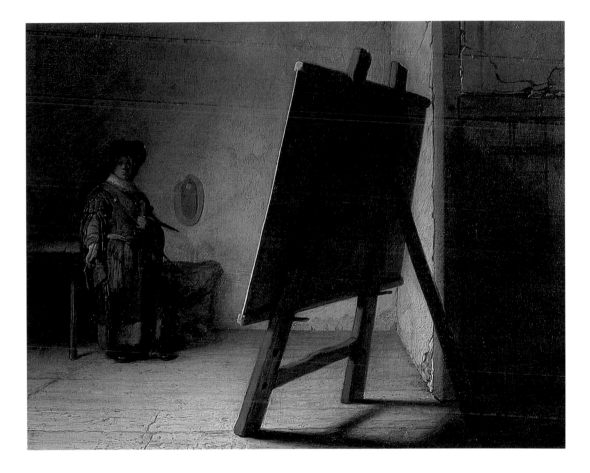

Andromeda

c. 1629
Oil on panel, 34.1 × 25 cm
L'Aja, Mauritshuis

In Rembrandt's work as a whole, this small panel of extraordinary dramatic intensity is the first painting we know of in which the artist depicted a mythological subject. The protagonist of the scene is Andromeda, the daughter of the king of Ethiopia and Cassiopeia. To punish the haughtiness of Andromeda's mother, who had boasted of her own beauty, Poseidon commanded that the girl be offered to a sea monster. Andromeda was tied to a rock when the hero Perseus saw her, killed the monster, and married her.

Rembrandt's painting departs from the iconographic tradition, as it focuses the story on the figure of the victim alone, without alluding to either the monster or the heroic liberator. Using the method of de-contextualization which becomes frequent in his later paintings, Rembrandt seems to enclose the assumptions and development of the story in the expression and attitude of the protagonist, capturing her at the crucial moment. It is possible that in drawing the figure of the girl the artist took inspiration from an illustration of a medieval manuscript conserved in the Leiden University library; the image was reproduced in an etching by Jacques de Gheyn II, which Rembrandt had certainly seen.

Andromeda is the first female nude that Rembrandt painted. Around 1631, the artist returned to this motif in two etchings, *Nude Woman Seated on a Mound* and *Diana at Her Bath*, for which he may have used the same model. The dating of this panel is further indicated by comparison with *Jeremiah Lamenting the Destruction of Jerusalem* (1630), in which some of the formal devices used in *Andromeda* are developed with greater maturity. The figure of the prophet is also constructed on a diagonal, and stands out against a luminous circle of light obtained by letting the gray of the prepared ground show through.

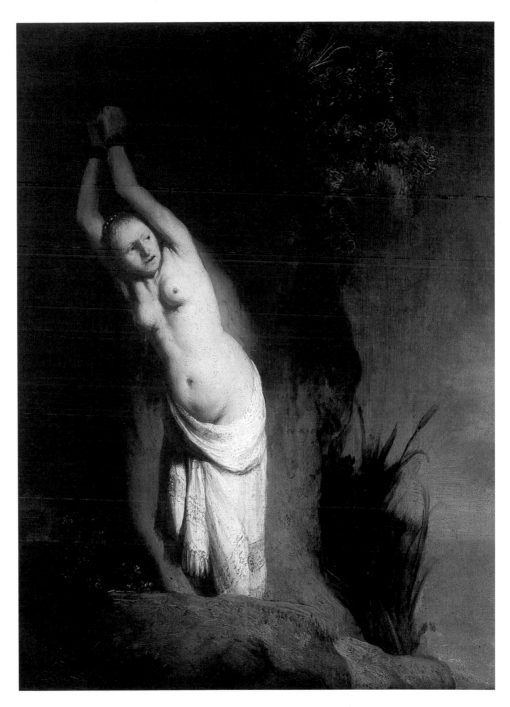

73

Jeremiah Lamenting the Destruction of Jerusalem

1630
Oil on panel, 58.3 × 46.6 cm
Amsterdam, Rijksmuseum
Signed and dated "RHL 1630"

This painting has a monumental structure and refined detail. In it, an old man with a rich robe and melancholy air sits alongside some ruins; against the backdrop to his right can be glimpsed a city in flames. The subject of this painting was correctly identified at the close of the nineteenth century, though earlier readings saw it as a depiction of Lot during the destruction of Sodom or Anchises facing the burning of Troy. However, the presence, at the base of the city walls, of a person leaving the city rubbing his eyes with his fists makes it clear that it is a depiction of the prophet Jeremiah sadly observing the destruction of Jerusalem. The person in flight would be King Zedekiah who abandoned the city and, captured by the army of the Chaldean king Nebuchadnezzar II, was blinded. According to Josephus Flavius's *Jewish Antiquities* (which Rembrandt owned in German translation), the prophet Jeremiah wanted to stay near the ruins of the city, shown in the painting.

The diagonal line of Jeremiah's figure, following a compositional principle typical of the baroque period, dominates the composition. The dynamic outline of his right side is enclosed by a luminous area, in which the yellow becomes so transparent that it lets the gray of the panel's ground preparation show through. The pigment used in painting the figure imbues the most precious details with life, as in the rich trim of the robes and carpet on which the prophet is resting. The braiding on the jacket was scratched into the fresh paint using the end of the brush handle. In the right-hand part of the painting the still life passage with embossed metal basin, cup, and amphora alludes to the treasures that, according to Josephus Flavius, Nebuchadnezzar wished to award Jeremiah. The book on which the prophet rests his elbow bears the inscription "BiBeL" (probably apocryphal) and alludes to the works of Jeremiah, author of the *Prophecies* and *Lamentations*. Dated 1630, this panel is one of the best from the late Leiden period.

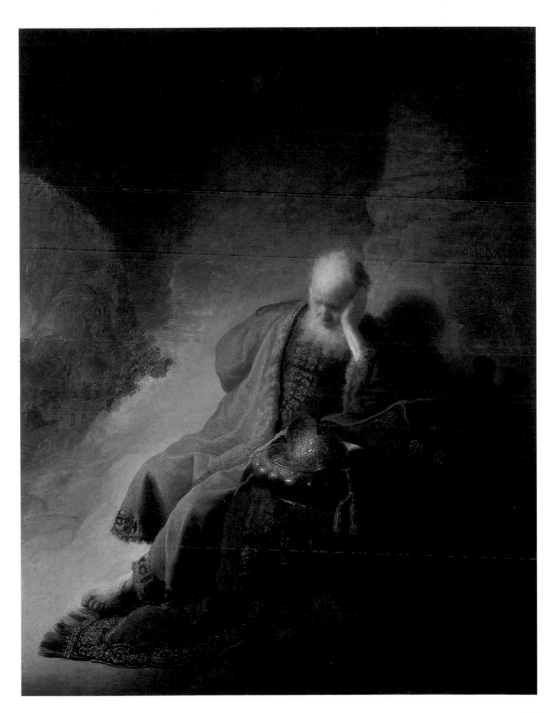

Portrait of Nicolaes Ruts

1631
Oil on panel, 116.8 × 87.3 cm
New York, The Frick
Collection
Signed and dated "RHL. 1631"

According to scholars, this was this first portrait Rembrandt made on commission, after lengthy practice in his youth with studies of heads and historical figures made from life models. The identity of the subject and the history of the panel are known with certainty: in 1636, the painting was in Susannah Ruts's store and identified as her father, Nicolaes. For the rest of the seventeenth century it remained in the family's possession. Later circulated on the antiques market, it eventually found its way into the Pierpont Morgan collection in New York, and thence into the Frick collection (1943).

Nicolaes Ruts was a rich member of the Amsterdam bourgeoisie who engaged in trade with Russia. In the portrait, the luxuriously fur-trimmed robe and the business letter held in his left hand illustrate the man's social position and occupation. The curious style of head-dress may allude to his relations with Russia, to which the presence of the fur may also refer as well. Ruts is shown in three-quarters view, with his face and gaze turned to the observer. The dynamic composition of the figure in this early work of Rembrandt's has qualities in common with works by Rubens and Van Dyck; perhaps Rembrandt was familiar with the classic examples of Flemish portraiture thanks to his relationship with Huygens and the court at The Hague, where Van Dyck had been called to work in 1631.

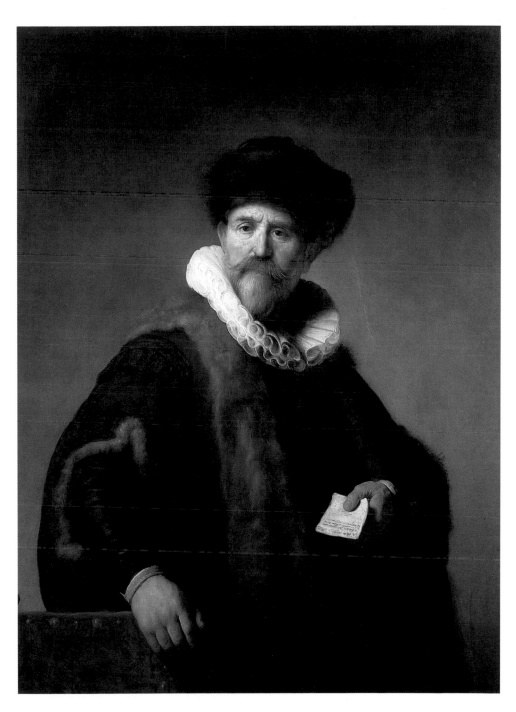

Rape of Proserpine

c. 1632
Oil on panel, 84.5 × 79.5 cm
Berlin, Staatliche Museen zu
Berlin, Preußischer
Kulturbersitz, Gemäldegalerie

In 1632 this panel was recorded in the inventory of the *stadhouder* Frederick Henry's collection at The Hague; by mistake, however, the *Rape of Proserpine* was indicated as the work of Jan Lievens. In later lists, it was instead, attribuited to Rembrandt, and critics have cast no doubt on this attribution. After the death of William III of Orange the painting ended up in Berlin for reasons of hereditary succession.

In contrast with *Andromeda*, in this composition Rembrandt included all the elements of the mythological account. Proserpine, the daughter of Jupiter and Ceres, was abducted by Pluto while she and some other girls were picking flowers by the edge of a lake. The god of the underworld dragged her into his realm and made her his wife. The light divides the scene into two distinct parts: on the left is the world of the living from which Proserpine was abducted, and on the right is the world of shadows, into which the god's chariot plunges. Rembrandt's exploration of dramatic effects yields magnificent results: the composition is constructed on the oblique line marked by the trajectory of the horses, and the gestures of the figures express all the violence and despair of the moment. While her companions grasp at her dress and try to hold her back, Proserpine wrests free of the god's clutches, and the god, to defend himself, twists his head.

According to some scholars, Rembrandt took his inspiration from Rubens for this painting, basing it on an etched reproduction of the Flemish master's version of the same subject. It may be that Costantijn Huygens, secretary to the *stadhouder* and great admirer of Rubens, showed the print to Rembrandt. Perhaps it was Huygens himself who proposed to the painter an alternative literary source to the traditional *Metamorphoses* by Ovid, namely, Claudian's epic poem of late classical antiquity, *De Raptu Proserpinae.*

The Anatomy Lesson of Dr. Tulp

1632
Oil on canvas,
169.5 × 216.5 cm
The Hague, Mauritshuis
Signed and dated "REMBRANDT.
F: 1632"

The first important commission after Rembrandt settled in Amsterdam came from members of the surgical guild who wished to have themselves portrayed within the context of an anatomy lesson. The painting was displayed in the guild headquarters where, in 1656, another work by Rembrandt, *The Anatomy Lesson of Dr. Deyman*, joined it. William I of Orange purchased the canvas in 1828 for the museum at The Hague.

The key figure of the scene is Dr. Nicolaes Tulp, shown on the right. Professor of anatomy at the surgical guild from 1628 to 1653, Tulp earned himself the title "Vesalius of Amsterdam." The Flemish anatomist Andreas Vesalius (1514–1564) was the first to personally perform a human dissection, exposing the tendons of the hand. He supported the theory that the hand is the doctor's main tool, attested by the origin of the term surgery (from Greek *kheirourgos*, working by hand: *kheir*, hand). The flattering comparison of Tulp to Vesalius is the concept behind the picture. In the painting the surgeon is dissecting an arm, and while he lifts the corpse's tendons with his right hand, with the left he indicates their function. In order to clearly depict this theme, Rembrandt did not respect the ordinary procedure for anatomy lessons, which started with the dissection of the abdomen and the head, as can be seen in the later portrait of Dr. Deyman. Here, instead, the artist offered an original interpretation of the group portrait genre, which usually called for the side-by-side lining up of the subjects. *The Anatomy Lesson of Dr. Tulp*, on the other hand, is a history painting that shows the man performing an act that holds the attention of all the people in the group. The operation carried out by the professor is closely followed by all those present, who compare it with what is illustrated in the book in the foreground.

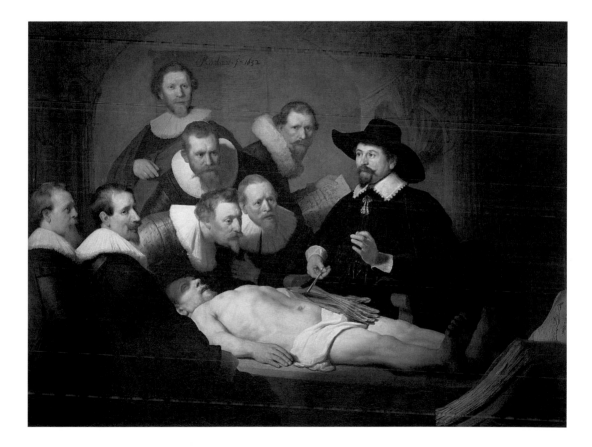

The Noble Slav

1632
Oil on canvas, 152.5 × 124 cm
New York, The Metropolitan
Museum of Art
Signed and dated "RHL VAN
RIJN 1632"

In 1632, Rembrandt painted the portrait of Amsterdam merchant Marten Looten, to whom this picture of a man in Near-Easten costume probably also belonged. It seems that in 1729, when the Looten collection was broken up, "A Turkish Prince or Grand Vizier, painted with skill and force by Rembrandt," was bought. The painting was again put up for auction in 1850, along with the entire collection of the deceased William II of Holland. In 1920, the last owner donated it to the New York Metropolitan Museum of Art.

The canvas shows an unknown Dutch model portrayed in a Near-Eastern style of costume; the life-sized figure stands out against a neutral background, most of which is in shadow. The man wears a cloak illuminated by golden highlights and an imposing white turban. Some details of the attire, such as the jewelry and the tassel falling over his shoulder, are handled with a great sense of the exotic, and they are striking for their vivacity. The canvas belongs to the genre of so-called Oriental-style heads, which had interested Rembrandt since his youth, initially with the intent of studying from figures from life to introduce into his biblical history paintings, and then for the sole purpose of painting evocatively rich and bizarre images. Owing to the lack of specific attributes, we have no way of knowing which Old Testament figure the painter had in mind for this picture.

The Noble Slav dates from the period when Rembrandt was moving to Amsterdam, when he preferred large formats for similar heads, and he made his first experiments with painting on canvas instead of panel. Like many works of his early years, this was probably made in competition with Jan Lievens, and indeed, there is a figure by the latter dressed and composed similarly, and also distinguished by a large white turban (Potsdam, Sansouci).

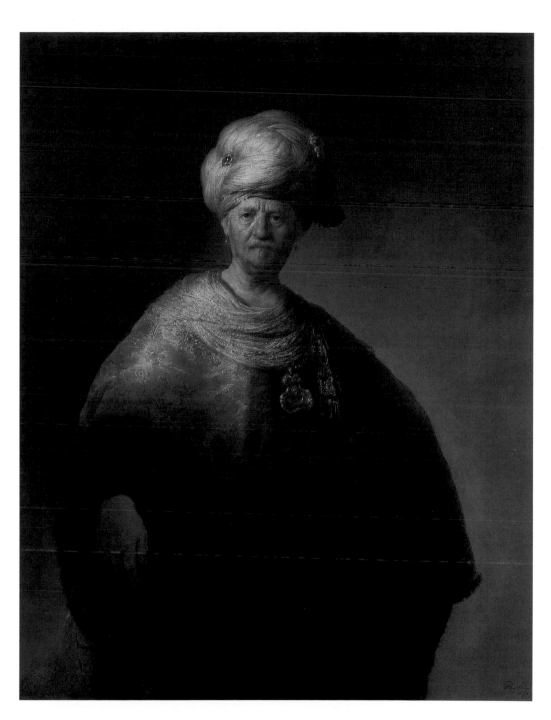

Deposition from the Cross

c. 1633
Oil on panel, 89.4 × 65.2 cm
Munich, Alte Pinakothek
Signed "CRHMBRANT" (added
later)

Between 1632 and 1646 Rembrandt made a series of seven paintings for *stadhouder* Frederick Henry of Orange, showing episodes from the Passion of Christ, including *Deposition from the Cross*, *Raising of the Cross*, *Ascension*, *Deposition in the Tomb*, *Resurrection*, *Adoration of the Shepherds*, and *Circumcision* (lost, but known from a copy). A group of seven letters written by the painter to Costantijn Huygens documents the economic aspects of the exchange, but does not shed light on the details of the commission: the prince probably purchased the *Deposition* in 1633 and asked for the other paintings later on. The paintings then made their way into the collection of the Elector of the Palatinate in Düsseldorf, and thence into the Munich Pinakothek.

The long period of the cycle's execution gave rise to some stylistic discontinuity, although the compositional principles remained uniform. It is possible that Huygens contributed to the layout, orienting Rembrandt toward classical models suited to the painting's conceptual goal. While there was no tradition of such subjects in Dutch painting (the iconoclastic tradition prohibited their use in the churches), fine examples could be found in contemporary Flemish paintings and in the work of the Renaissance masters. Thus, for *Deposition from the Cross*, reference was obviously made to a painting by Rubens for the Antwerp cathedral (1612), known to Rembrandt through a reproduction engraved by Lucas Vorsterman. Among the variations introduced by Rembrandt the dramatic lighting stands out, drawing attention to Christ's lifeless body, supported only with difficulty by his rescuers. To the left of the painting is the episode of Mary fainting, which was rejected by the Catholic doctrine of the Counter-Reformation and chosen by the painter as a further element of pathos. As in the *Ascension*, reference to classical models is evident, and scholars see in the figure of Christ a revisitation of Titian's *Assumption of the Virgin* in the church of Santa Maria Gloriosa dei Frari in Venice.

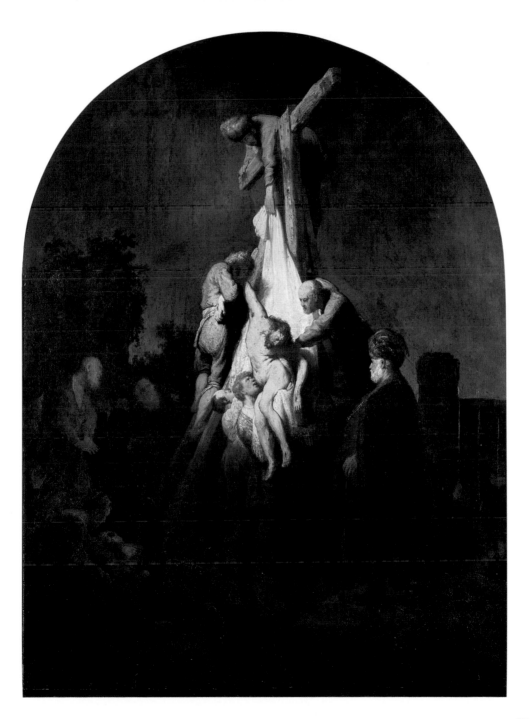

85

Portrait of Saskia with Hat

c. 1633, retouched in 1642
Oil on panel, 99.5 × 78.8 cm
Kassel, Staatliche Museen
Kassel, Gemäldegalerie Alte
Meister

The history and meaning behind this portrait of Saskia are not entirely clear. From x-ray analysis it seems reasonable to think that Rembrandt himself retouched the painting after completing the first version. The most convincing hypothesis is that the work was first made around 1633, when the painter did various informal portraits of his young fiancée. The date is deduced from comparison with the *Portrait of Amalia van Solms* of 1632 (Paris, Musée Jacquemart-André), which shows the same profile pose. Scholars do not agree about to what degree the portrait was finished, nor about the iconography chosen for it; according to some, the panel originally showed Saskia as the Roman matron Lucretia in the act of stabbing herself. The painting remained in Rembrandt's studio and the painter modified it, perhaps after his wife's death in 1642. In this second phase, the additions made included the peacock feather on the hat and the fur stole slipped over her right shoulder. Some interpretations suggest that these elements allude to the theme of *vanitas*, that is, the fleeting nature of earthly things. The woman's opulent attire can also be read in this key: a similar dress appears in an etching by one of Rembrandt's pupils, entitled *The Time of Death*. There is also an hypothesis that Rembrandt drew his inspiration from Renaissance models for this dress, intending to celebrate his spouse's nobility; reference is also made to the woman's aristocratic origins by her position in profile, which is rather unusual in Rembrandt's repertoire.

Around 1652 Rembrandt sold the *Portrait of Saskia with Hat* to Jan Six; in 1734, when Six's heirs sold it to a collector in Delft, the painting bore the inscribed date 1642, which seems to confirm that retouching was done at the time of the woman's death. Later tampering led to the loss of the inscription and repainting of the background.

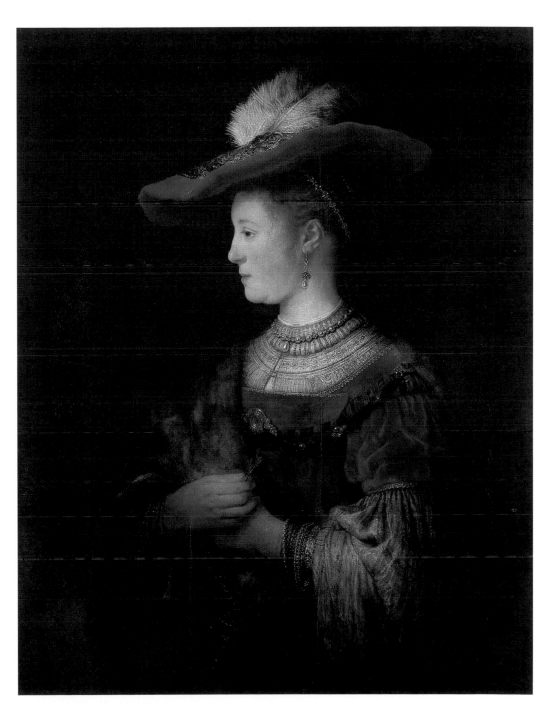

Diana Bathing with Her Nymphs and Stories of Actaeon and Callisto

1634
Oil on canvas, 73.5 × 93.5 cm
Anholt, Museum Wasserburg
Anholt
Signed and dated "REMBRANDT.
FT. 1634"

Nothing is known about the origin of this painting, which was first mentioned in a Parisian auction of 1774. The composition is atypical with respect to Rembrandt's other mythological paintings, differing in the number of figures, the handling of the landscape, and the choice of colors. The originality of this picture is even more significant considering that it represents a unique example in his iconography.

Against the backdrop of a luminous landscapes modulated with shades of green and turquoise, Diana bathes with her nymphs, who are portrayed in the foreground. The idyllic scene is disturbed by two dramatic events at the lake's edge, to either side of the painting. On the left, the young hunter Actaeon bursts in on the scene, glimpsing the goddess's nudity: the chaste Diana punishes him by turning him into a stag and leaving him to be torn apart by his own hounds. On the right, the nymphs discover the pregnancy of Callisto, lover of Jupiter: according to myth, Diana punished Callisto for having broken her vow of chastity to the goddess, transforming the nymph into a bear and unleashing her dogs on the animal. Rembrandt merges for the first time ever the two episodes, narrated in two separate books of Ovid's *Metamorphoses*. For the setting and a few of the narrative cues he drew inspiration from Italian Renaissance engravings, in which, however, the two episodes were always treated separately.

In the sweeping landscape, the figures stand out for the luminosity of their flesh and the realistic liveliness of their gestures and poses, fruit of the master's original imagination. The narrative unity of the whole is created by the figures' movements and gazes, which connect all three groups of the composition. On the extreme left, the detail of the two dogs fighting seems to suggest the tragic epilogue to the events.

Saskia Dressed as Flora

1634
Oil on canvas,
124.7 × 100.4 cm
St. Petersburg, The State
Hermitage Museum
Signed and dated "REMBRANDT
F (..)34"

The motif of a female figure adorned with flowers recurs often in Rembrandt's oeuvre: scholars agree in recognizing such images as depictions of Flora, the goddess of springtime and flowers. Supporting this interpretation, among other things, is a note by the painter that he had two of his pupils paint Flora as well. There are no sure clues for establishing the purpose of these paintings. It is not certain whether they should be considered primarily portraits in costume, in which the artist immortalized the likeness of his beloved dressed in a fanciful costume with the symbols of a pagan divinity. Since the physiognomy of this Flora is almost unanimously recognized as that of Saskia, we can only guess that instead of a portrait, the artist wished to paint a historical figure, and that he simply used his wife as model. In another interesting interpretation, the repetition of this theme can be explained in light of a precise historical phenomenon; in the first few decades of the seventeenth century in Amsterdam, the passion for tulips had become a sort of collective mania of great economic importance. It could be that flower collectors sought out pictures like this one.

In the painting, Saskia is shown in profile, with her face turned toward the viewer; her right hand holds a flowery staff, one of the goddess's attributes, while the left hand gathers up the folds of her gown. This gesture appears in some works by the Dutch masters of the Renaissance, such as *Giovanni Arnolfini and His Wife* by Jan van Eyck. Rembrandt may have imitated it with the aim of enhancing the picture's aura of antiquity. In the careful definition of the embroidery, silk, and flowers, the painter offered proof of the same skill used in other portraits of the same period.

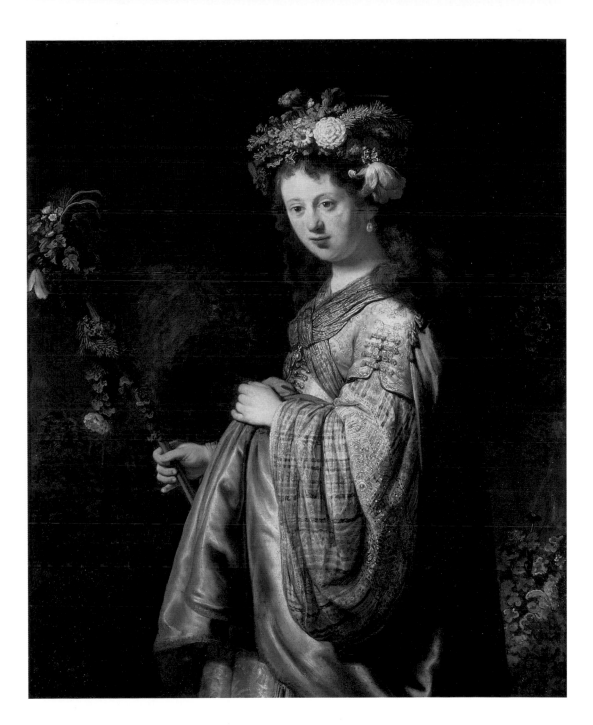

Artemisia Receives the Ashes of Mausolus (Sophonisba Receives the Poison Cup)

1634
Oil on canvas, 142 × 153 cm
Madrid, Museo Nacional
del Prado
Signed and dated "REMBRANDT
F:. 1634"

Among Rembrandt's history paintings, this is one of the most controversial from an iconographic standpoint, and not even the most recent and most thoroughly documented studies have reached agreement. In the painting there is a richly dressed woman whose opulent robes and jewelry would suggest that she is a queen; the majesty of the figure further confirms this indication. While the woman raises a hand to her breast, a handmaiden offers a splendid cup, holding it in a veil. Against the dark background an old woman can be made out, where it appears that another hand painted over Rembrandt's original figure bearing a round object.

Iconographic interpretations have proposed two different subjects from ancient history: Artemisia receiving the ashes of Mausolus, or Sophonisba receiving the poison cup. Sophonisba, wife of King Syphax of Numidia and ally of the Carthaginians, was taken prisoner by Masinissa, who promised her protection from the Romans. Unable to keep the promise, he sent her a messenger with a cup of poison; to avoid falling into the hands of the enemy, she drank it and died. The theme of the cup also appears in the story of Artemisia, wife of the satrap Mausolus: when her husband dies, the woman has a magnificent tomb built and, wishing also to make herself the living tomb of her loved one, she drinks his ashes mixed with a beverage. In the figurative tradition, Artemisia is usually represented at the moment when the ashes are poured into the cup. This is the case, for example, with a painting by Rubens that was added to the *stadhouder*'s collection around 1632, and that Rembrandt may have seen. The elements in the painting, and in particular the controversial figure of the old woman, do not permit a definite identification. Independently of her identity, this regal personage is similar to other historical figures of the mid-thirties, such as *Saskia Dressed as Flora* (London, National Gallery), and *Bellona* of 1633, at the New York Metropolitan Museum of Art

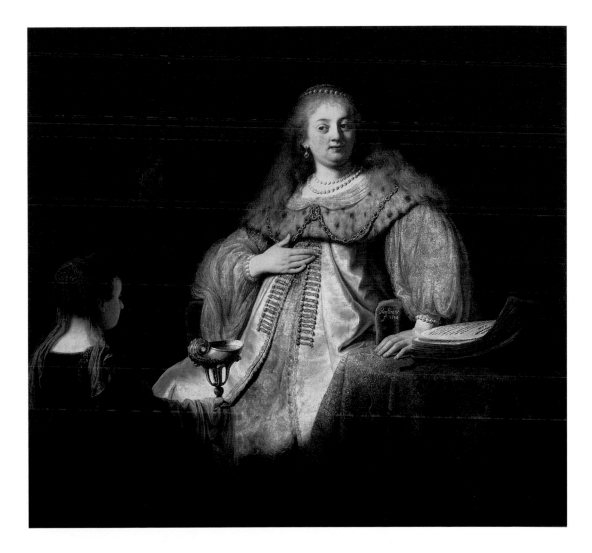

Holy Family

c. 1635

Oil on canvas, 183.5 × 123.5 cm
Munich, Alte Pinakothek
Signed and dated "REMBRANDT
F. 163(.)"

The earliest information we have about this painting suggests that it was requested or purchased by Maerten Soolmans and Oopjen Coppit, who commissioned their full-figure wedding portraits from Rembrandt around 1634. The refined taste of the patrons may explain the elegance of this holy scene, in which particular attention is given to the detailed description of the Madonna and Child, and the physiognomy of Joseph. Among the first large-format paintings that Rembrandt dedicated to figures of religious history, the canvas was tampered with in the course of the eighteenth century to adapt it, so it seems, to a fireplace. The original proportions of the composition were thus lost, along with part of the figuration on the area to the left, where there may have been a fire, the source of the light illuminating the scene. After the eighteenth-century cuts, it may have been necessary to rewrite the original signature, and with it the date, which was not correctly transcribed. The painting found its way into Munich' s Pinakothek from the collection of the Elector Prince of the Palatinate, who had purchased it on the antiquities market.

The *Holy Family* is depicted in an interior defined by the pattern of light and shade; on the rear wall, Joseph's carpentry tools can be made out. Next to the cradle, the Madonna holds the Baby in her arms and caresses his feet, as if to warm them; this gesture, foreign to the Dutch iconographic tradition, may have come from the study of Italian models, such as Titian and Annibale Carracci. On the right of the scene, the pose of Joseph is the same one that Rembrandt used for the figure leaning forward in *The Anatomy Lesson of Dr. Tulp*.

The likely commission from Soolmans, along with some stylistic features (the monumental size of the figures, the color use, and the penchant for a vague background that contrasts with the minute definition of the figures), has led critics to propose the work was painted around the mid-sixteen-thirties.

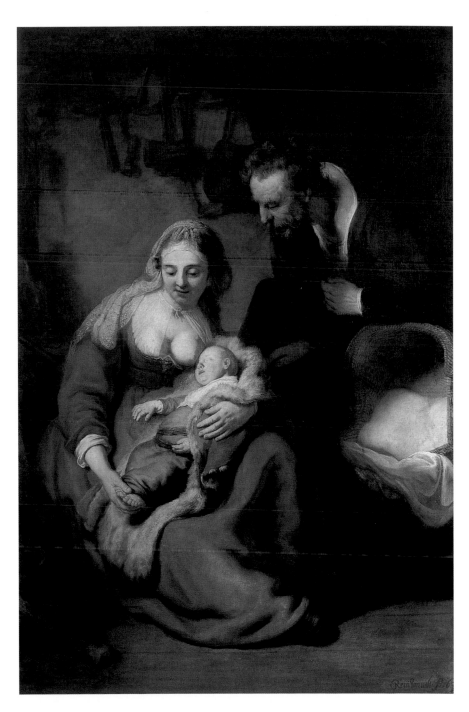

Rape of Ganymede

1635
Oil on canvas, 177 × 130 cm
Dresden, Staatliche
Kunstsammlungen Dresden,
Gemäldegalerie Alte Meister
Signed and dated "REMBRANDT.
FT 1635"

The painting, recorded on the antiquities market since 1716, was purchased in 1751 by Frederick Augustus II of Saxony. Many classical authors describe the myth depicted: the beautiful boy Ganymede, son of King Tros of Troy, was carried off by Zeus in the guise of an eagle. The god wanted to make the boy his lover, and carried him to Mount Olympus, where he became the gods' cupbearer. He was later turned into the constellation of Aquarius, thus becoming immortal.

In Rembrandt's interpretation, Ganymede is a frightened, crying baby snatched by an eagle in flight. The only source of light in the dark sky is Zeus's lightning bolt, which can be glimpsed in the upper left; the brightest part of the composition is the face and figure of the child, who occupies the center of the painting. The realism of the scene is heightened by a few details: seized from his life on earth, Ganymede clasps a handful of cherries in his fist, and in his terror, he urinates. In a preparatory sketch for this painting, Rembrandt had even planned to include the parents who, gaze turned skyward, watch helplessly as their child is carried away.

In the iconographic tradition, which included Michelangelo among its most important interpreters, Ganymede was shown as a young man; compared with these compositions with their classical, heroic aura, Rembrandt's image looks unconventional and almost satirical. Critics, investigating the meaning of the painting, have proposed that this was an interpretation of complex symbolic themes. Historically, in fact, the myth of Ganymede has been interpreted as an allegory for the soul, which in its purity yearns for god; this would explain the choice of giving the hero a baby's features. Similarly, Ganymede, who was transformed into Aquarius, may symbolize the winter and its rain; Rembrandt's painting would allude to this with the element of the urine, which, falling to earth, revives life.

The Sacrifice of Isaac

1635
Oil on canvas, 193 × 132.5 cm
St. Petersburg, The State
Hermitage Museum
Signed and dated "REMBRANDT.
F. 1635"

As with other important paintings by Rembrandt, the first reports we have of this work are late, and attest only to its circulation on the antiquities market. We have no way of knowing whether *The Sacrifice of Isaac* was made on commission or simply bought by a customer passing through the artist's workshop.

The subject is taken from Genesis, and depicted here with absolute fidelity to the biblical text: in the canvas, the angel is shown arresting Abraham's hand as he, obeying God's command, is about to sacrifice his son Isaac. We are at the climax of the dramatic action when the sudden appearance of the divine messenger profoundly alters the course of events. The hand of the angel blocks that of Abraham, who drops the curved dagger that he was about to use to slit Isaac's throat: the weapon is immortalized while suspended in its fall. With the other hand, the patriarch still holds his son's head in a dramatic grip; Isaac's tragic nudity is the brightest spot of illumination in the entire composition.

The construction of the scene and the monumentality of the figures, together with the narrative focus, associate this canvas to similar baroque Italian creations (Tintoretto, Carracci, and Caravaggio), and betray the inspiration taken from a precise model by Rembrandt's teacher, Lastman. The scale of the painting and its execution are similar to those in other sacred scenes of the mid-sixteen-thirties, such as the *Holy Family* now in Munich, and *Belshazzar's Feast*. Later, in Rembrandt's shop, another version of the painting was made (Munich, Alte Pinakothek) that differs in a few compositional elements; it may be that the master, dissatisfied with the results achieved in the first painting, assigned a pupil the task of translating his second thoughts into a new painting.

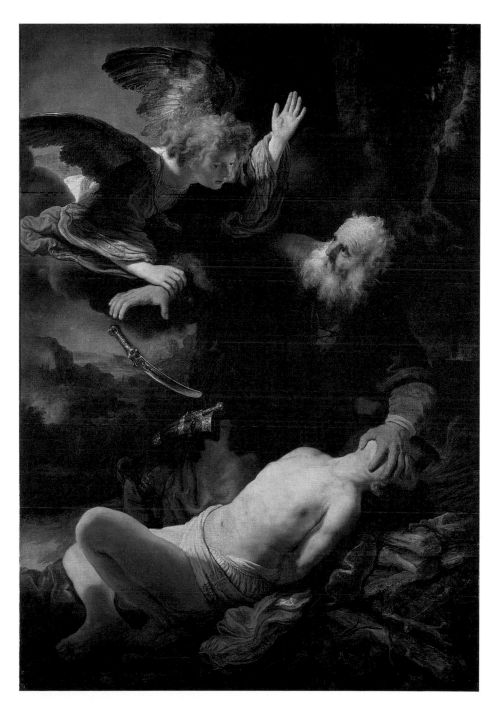

Saskia Dressed as Flora

c. 1635
Oil on canvas, 123.5 × 97.5 cm
London, National Gallery
Signed and dated "REM(B.)A(...)
1635" (added later)

The subject of this work is disputed, since, as with the St. Petersburg Flora, it is not clear whether it should be considered a portrait in costume or a history painting for which the painter used his wife as model. It is not even certain whether the figure's painted features correspond to Saskia's, or to another model the artist often painted in the years around 1635; there are clear similarities between this figure and the *Artemisia* of 1634. There are no records of the original owner of this painting, since nothing is known about it before a Parisian auction in 1756. X-ray analyses have revealed an earlier version in which the female figure represented Judith with the head of Holofernes. The signature and date were probably added during a restoration, made to accurately copy an original inscription removed in the process.

The luminous figure of Flora stands out against a dark and practically uncharacterized background; she is the goddess of the springtime and vegetation. The description of the costume plays a decisive role in the canvas: it is depicted in broad areas of color and passages of minute by detailed trimmings. It is possible that Rembrandt wished to celebrate his wife's first pregnancy here through the myth of fertility, or that he was trying to give his own, original interpretation to a rather popular, widely used motif in seventeenth-century Holland—that of the shepherdess, which many artists painted as a genre scene or as a portrait.

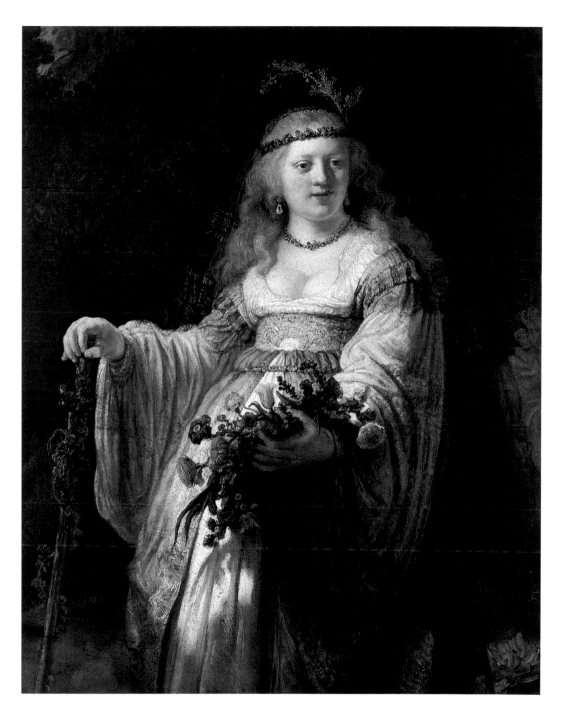

Belshazzar's Feast

c. 1636
Oil on canvas, 167.6 × 209.2 cm
London, National Gallery
Signed and dated "REMBRAND.
F. 163(.)"

This painting, of which nothing is known before the eighteenth-century activity recorded on the collectors' market, shows a biblical episode recounted in the Book of Daniel. The scene's protagonist is Belshazzar, the Babylonian prince, who decided to organize a banquet for his court just as the Persian King Cyrus was laying siege to the city. During the feast, a mysterious inscription appeared on the wall, which only Daniel could read; it was the prophesy of Belshazzar's death and the passage of his kingdom to Median and Persian rule. In the painting, the sudden divine manifestation provoked a violent reaction. Those present recoil in fear, and the prince, himself terrified, knocks over a chalice.

Gloomy tones dominate the canvas, and the mood is set by the unusual use of a dark ground; the supernatural inscription and a light outside of the picture act as opposite sources of illumination. Belshazzar's brocade cloak and the passage of still life on the table are outstanding for their painterly quality. According to the Bible, the gold and silver goblets that Nebuchadnezzar had taken from the temple in Jerusalem were used for the banquet; it was this impious act that provoked Belshazzar's condemnation. In accordance with Dutch custom, the painting, with its clearly moralistic content, was well suited to the décor of a dining room because of its subject matter.

In the inscription bearing the signature, the last figure of the date is illegible. Therefore, in considering its date, precedence was given to stylistic characteristics, such as the painting's parallels with *Sophonisba* (1634) and *Sacrifice of Isaac* (1635). Furthermore, scholars believe that the Cabbalistic inscription in Hebrew characters was suggested to the painter by Rabbi Menasseh-ben-Israel, his neighbor: the writing is identical to one that appeared in a book of his, published in Amsterdam in 1639. Rembrandt had known the rabbi since at least 1636, when he made an etched portrait.

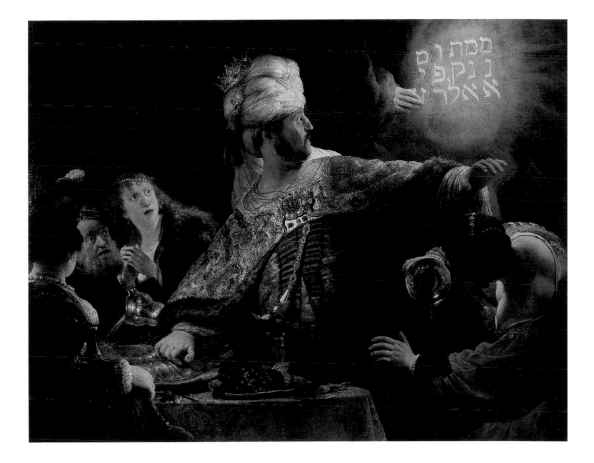

The Prodigal Son Squanders His Inheritance (The Happy Couple)

c. 1636

Oil on canvas, 161 × 131 cm
Dresden, Staatliche
Kunstsammlungen Dresden,
Gemäldegalerie Alte Meister
Signed "REMBRANDT F."

This painting can probably be identified as the double portrait of Rembrandt and Saskia mentioned in 1677 in the estate of the widow of Louys Crayers, who had been Titus van Rijn's tutor. Traditionally, the painting was recognized as a self-portrait and indicated by the title *The Happy Couple*. It is thus believed that the painter meant to represent himself and his wife in an image of conjugal happiness.

The nature of the work, however, is more complex. Closer study of its iconography makes it possible to associate this scene with the evangelical tale of the prodigal son who squanders his inheritance in a tavern, in the company of prostitutes. In particular, some of Rembrandt's drawings dedicated to this theme show striking similarities with the painting. X-ray analyses seem to confirm this interpretation: at some point in time, and perhaps by Rembrandt's own hand, the canvas was cut on the left-hand side and divested of a large portion, and an already sketched-out figure of a scantily dressed musician was concealed by painting over it. The painter perhaps meant to eliminate some minor figures in order to concentrate on the protagonists, as he did with many history scenes of the mid-sixteen-thirties.

The identification of the subject does not exclude, however, that the likenesses are of Rembrandt and Saskia: confirmation is easily obtained through comparison with other portraits of the same period. In the uncertainty of whether the canvas should be considered a portrait in costume or a history scene for which the artist personally posed, it should be pointed out that Protestant artists appreciated the theme of the prodigal son for the didactic value of the story of the fall and redemption. If the painting really was given to the family of the tutor Crayers, it only strengthens the hypothesis that it was a self-portrait with a moralizing tone

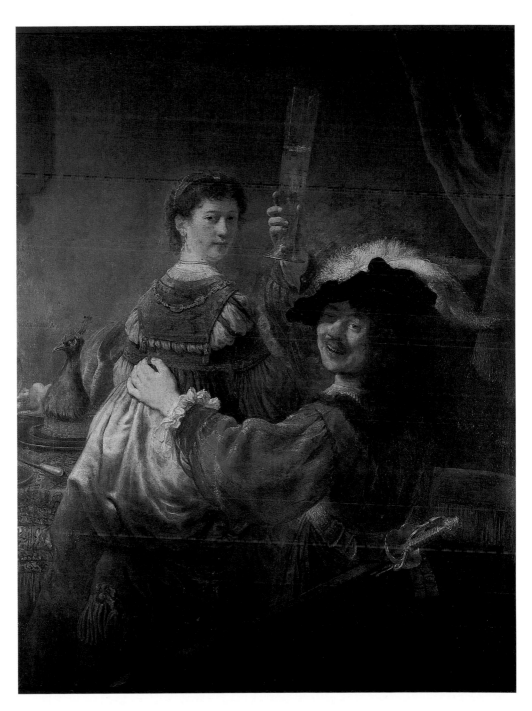

Danaë

c. 1636 with retouches
Oil on canvas, 185 × 203 cm
St. Petersburg, The State
Hermitage Museum
Signed and dated "REMB(...) F
1(..) 6"

This painting can be recognized among Rembrandt's possessions described in the 1656 inventory, and it evidently languished at length in the painter's studio. The artist retouched it years after the first version was finished; x-ray analyses attest to extensive repainting, which for the chromatic richness and the fine modulation of the brushstrokes would seem to date from the period of *The Night Watch*. The subject has often been distorted, but there is no doubt that this painting shows a myth taken from Ovid's *Metamorphoses*: Danaë, daughter of King Acrisius, was locked away by her father, who wanted to prevent her from conceiving a child because an oracle had warned him that he would die at the hand of his own grandson. The prophesy came true anyway, since Zeus, transforming himself into a shower of gold, managed to visit the girl. From their union Perseus was born, and he later did kill the king, during a javelin throwing contest.

This painting shows the encounter between Danaë and Zeus: the girl becomes aware of the divine presence, which takes the form of a warm, golden light that pervades everything. In the iconographic tradition, this representation spread together with the more conventional one in which the god appears in the form of a shower of gold coins. By making this choice, perhaps Rembrandt wished to draw attention to the spiritual side of divine love. The gold sculpture set at the head of the bed may allude to the theme of purity: the depiction of Anteros, a crying Cupid with his hands tied, can be interpreted as a symbol of pure love and chastity.

The fineness of the light and the virtuoso description of the fabrics and richly canopied bed make this canvas one of the best of the artist's baroque period. In 1985 *Danaë* suffered serious damage after a vandal splashed acid on it.

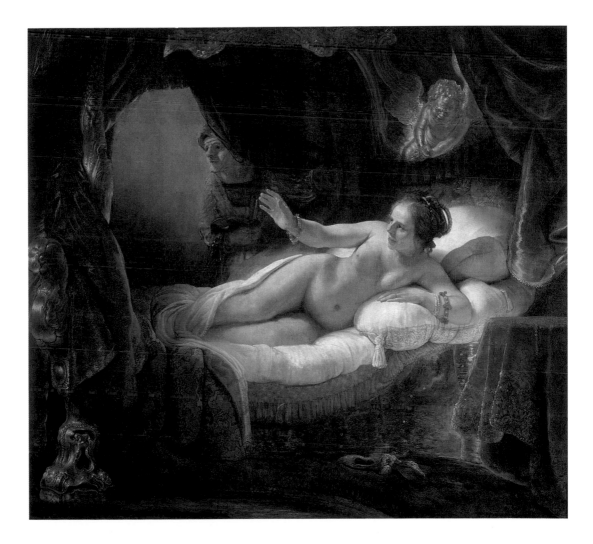

Girl with Dead Peacocks

c. 1636

Oil on canvas, 144 × 134.8 cm

Amsterdam, Rijksmuseum

Signed "REMBRANDT" (perhaps added later)

This painting, which originally belonged to an Amsterdam family, represents a rare exception in Rembrandt's thematic repertory. It is a genre painting, even if it is difficult to ascribe it to a precise category; it departs from the canons for the still life as much as it does from those of the kitchen scene, both of which enjoyed great popularity in seventeenth-century Holland.

In a precise frame created by the stone windowsill, a girl pensively looks at the two dead peacocks that dominate the foreground. One of the two is laid on the sill, while the other hangs by its feet from the shutter; the composition is completed by a basket of fruit half-concealed by the bodies of the birds. The painter shows great skill in the rendering of the peacock's plumage, describing the iridescent colors and the different feather textures. In traditional still lifes, the elements are not so rigorously selected, but are often multiplied, diversified, and accumulated; furthermore, no human element ever appears in them. In Dutch kitchen scenes, the still life merges with the depiction of individuals, but these are usually florid young women and not absorbed little girls. However, _Girl with Dead Peacocks_ can be associated with the two genres for its symbolic meaning, which has two modes of interpretation. In the first place, the theme of the peacock can be considered a hommage to the beauty of creation, and therefore to divine power; nevertheless, we should not overlook the allusion to the vanity of earthly things, which are inevitably subject to death and destruction.

The date of the painting is linked for its thematic and stylistic affinities with the painting known as _Self-Portrait with Bittern_ (Dresden, Galäldegalerie), dated 1639; Rembrandt shows himself in the guise of an aristocratic hunter hanging a dead bittern on a hook.

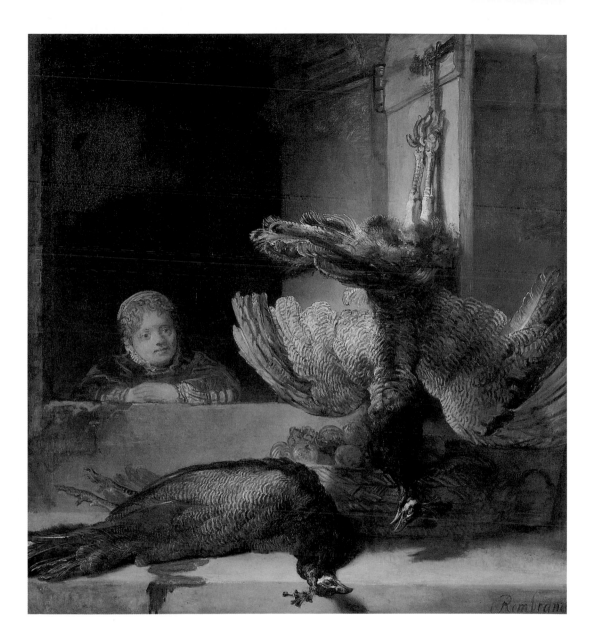

Self-Portrait with Embroidered Shirt

1640

Oil on canvas, 93 × 80 cm
London, National Gallery
Signed and dated "REMBRANDT
F 1640" (apocryphal?) and
added by others,
"CONTERFEYCEL"

In 1861 the National Gallery in London purchased *Self-Portrait with Embroidered Shirt* from the heirs to a Parisian collection: the earlier history of this painting is not known, even though it fills a fundamental role in the definition of Rembrandt's artistic personality. The canvas shows an execution of extraordinary refinement: the figure of the painter is plastically defined by a soft light that modulates the colors in a great variety of shades. As elsewhere, Rembrandt depicts himself *en travesti*: he wears the elegant jacket of a sixteenth-century nobleman, an embroidered shirt with starched collar, and a large hat. The artist is seated in three-quarters pose, and rests his right arm on a railing, over which the full jacket sleeve drapes. The figure's pose and the presence of the railing suggest a precise Italian model for the painting, of which Rembrandt had first-hand knowledge—the portrait by Titian known as *Ludovico Ariosto* (London, National Gallery), which was at the time in the collection of Alfonso López in Amsterdam. This merchant lived in the Dutch city from 1636 to 1641; during this period he purchased a youthful painting from Rembrandt and bought at auction the *Baldassare Castiglione* by Raphael (Paris, Musée du Louvre). Rembrandt also attended the auction, and made a sketch of the fine portrait; there is no doubt that the painter also had this model in mind when he did his self-portrait, although it is not directly quoted except in the style of hat.

From an analysis of the relationship with the models, we can surmise that Rembrandt wished to emulate the great Italian masters; he seems even to declare his spiritual affinity with the aristocratic and cultural milieu of the Renaissance evoked by the figures of Ariosto and Castiglione.

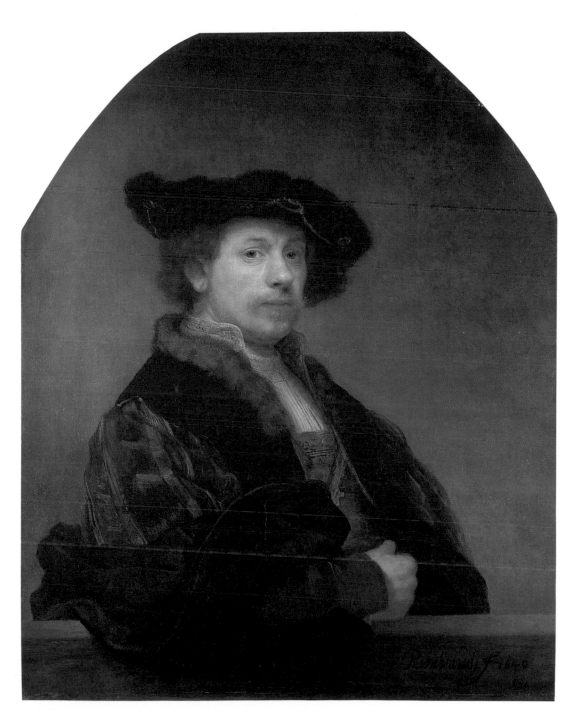

111

Portrait of Agatha Bas

1641
Oil on canvas, 105.2 × 83.9 cm
London, Buckingham Palace,
Royal Collections
Signed and dated "REMBRANDT.
F 1641"; inscribed "AE 29"

The portrait of Agatha Bas was conceived *en pendent* with that of her husband Nicolaes van Bambeeck, now in the Musées Royaux des Beaux-Arts in Brussels. The two paintings, mentioned for the first time in 1805 by an Amsterdam art merchant, were divided in 1814, and five years later, that of Agatha entered the British royal collections. In the two portraits, the elegant clothing and the refinement of pose and bearing match the rank of the patrons: he was a successful fabric merchant, and she was the daughter of an Amsterdam burgomaster. The canvases have the same compositional layout: the half-length figures dominate the space within the painted ebony frame, cambered and decorated with capitals. Rembrandt used this illusionistic element to create *trompe l'oeil* effects: for example, the woman rests her left hand on the frame, while her fan protrudes into the observer's space. Before a dark, undefined background, Agatha appears in full light; her face is brightly illuminated and described with extraordinary intensity. Rembrandt lingers over the woman's rich attire: the shawl-collar, the embroidered camisole, cuffs, fan, pearls, and jewelry are painted with a lively sculptural and painterly sensibility. The beauty of the image invites comparisons with the *Portrait of Maria Trip* (Amsterdam, Rijksmuseum), which Rembrandt did in 1639 with equal attention to the faithful rendering of details. For the portrait of Nicolaes van Bambeeck, instead, the master borrowed a few motifs that he had already used in the *Self-Portrait with Embroidered Collar* (1640), replacing the railing with the illusionistic ebony frame.

113

Portrait of Cornelis Claeszoon Anslo
and His Wife Aaltje Schouten

1641
Oil on canvas, 176 × 210 cm
Berlin, Staatliche Museen zu
Berlin, Preußischer
Kulturbesitz, Gemäldegalerie
Signed and dated "REMBRANDT
F.1641"

In 1640, Rembrandt made and signed two drawn portraits of the merchant and Mennonite preacher Cornelis Claeszoon Anslo (1592–1646). These studies document the first stages of the painter's relationship with the rich patron, who later had his own portrait made in an etching, and then in a painting. The painting, which until around 1780 remained in Amsterdam in the possession of his heirs, was purchased by the Berlin museum in 1894.

In the canvas, as in the etching and the drawings associated with it, Rembrandt wished to show the patron's preaching activity, emphasizing his knowledge of the Holy Scriptures. He is shown at his writing table in a studio where a bookshelf covered with draperies can be made out in the background; a few books rest on the table, one of which is open and placed on a stand. Next to Anslo sits his wife Aaltje Schouten, shown wearing a severe black dress. The light shines from the left and illuminates the objects on the table and the faces of the two figures, who are painted with extreme sensibility.

In conceiving this monumental double portrait, Rembrandt took on the problem of the interaction between the two figures, in order to make the scene more effective and realistic. The theme tackled by the painter in various other works, starting with his experience of the history paintings, was resolved here in the form of a dialogue. The preacher, leaning forward on his chair, indicates the open book with his left hand, while with his gaze he turns to his wife, who listens carefully to him. This narrative device, the grandiose conception, the use of light, and the broad brushstroke technique all relate the portrait of the Anslos to the stylistic and formal achievements of *The Night Watch*.

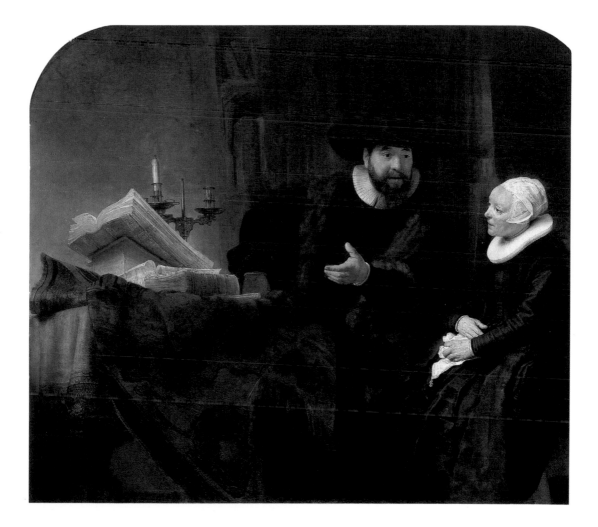

Accord in the Nation

c. 1642
Oil on panel, 74.6 × 100 cm
Rotterdam, Museum Boijmans
Van Beuningen
Signed and dated "REMBRANDT.
F. 164(.)"

Along with two other monochromatic works, this allegorical panel was in Rembrandt's studio in 1656, when the first inventory of the painter's possession was drawn up. It was listed as "The Unity of the Nation."

The purpose of this work is not clear: it has been proposed that it was a sketch for a painting, and some have even perceived in it an embryonic idea for *The Night Watch*. The symbolic content has also suggested that this composition could be related to the displays organized for Frederick Henry's entrance into Amsterdam in 1642. However, the picture also shows significant affinities with the category of political prints, and it could be a sketch for a never-realized etching; this would explain the panel's lengthy permanence in the artist's studio. In anticipation of a broad diffusion, it was customary to accompany this kind of image with explanatory captions, and in the upper and lower areas of the painting are two white bands for this purpose.

Interpretation of the iconography is problematic, since some symbolic elements remain obscure still today; the difficulty is magnified by the fact that in the absence of a sure date, we cannot establish a precise relationship with Dutch history. In the left-hand area, the most complex, we can see an allegory of the constitution of the Netherlands; at the center Amsterdam and the confederate cities are represented, and to the right is an animated group of soldiers. The allegory may refer to a conflict that broke out at the start of the sixteen-forties between the city of Amsterdam and Frederick Henry over the military policies the *stadhouder* pursued.

For its narrative structure and use of symbolic elements, *Accord in the Nation* seems to date from the same years as *The Night Watch*. The similarity is particularly clear in the group of soldiers to the right of the composition.

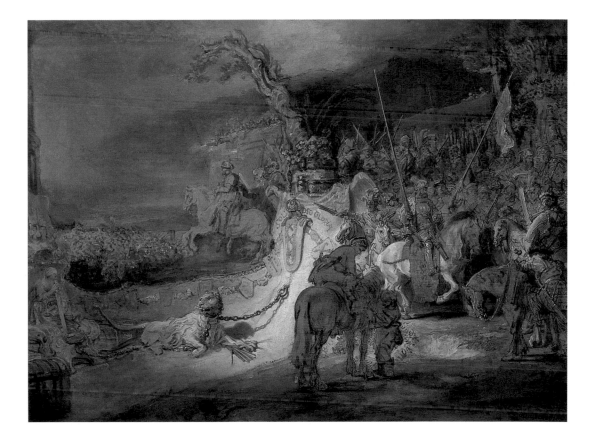

117

The Shooting Company
of Captain Frans Banning Cocq
(The Night Watch)

1642
Oil on canvas, 363 × 437 cm
Amsterdam, Rijksmuseum
Signed and dated "REMBRANDT
F 1642"

This painting, commonly known as *The Night Watch*, was commissioned to decorate the main hall in the Amsterdam Civic Guard headquarters: it is a group portrait, showing the members of the arquebusier militia together with their captain, Frans Banning Cocq. In 1715 the painting was moved to the War Council Office of the Amsterdam town hall, and was also cropped to fit a smaller space. Toward the close of the eighteenth century, the thick layers of dark varnish accumulated over time gave rise to the idea that it was a picture of a night patrol, hence the title *The Night Watch*.

As he already had in *The Anatomy Lesson of Dr. Tulp*, Rembrandt interpreted the group portrait as a scene of history. At the center, next to the captain, Lieutenant van Ruytenburgh gives the order for the company to march; preparations for the deployment begin. The many secondary figures dressed in historical costume enhance the composition's narrative value. Rembrandt also introduced a few symbolic elements into the story, so that the picture can be read as a celebration of the militia and its role in city life. In particular, the girl dressed in yellow in the middle ground, apparently a vivandier, brings an important element into the scene; the chicken slung from her belt is an allusion to the arquebusier militia symbol, which included two chicken's talons.

The artist orchestrated the composition according to dynamic forces: as in a theatrical scene, the figures emerge from a dark, undefined ground and move toward the observer, illuminated by light sources external to the picture itself. Rembrandt lingered insistently on the individual portraits, minutely describing their physiognomies, attire, and arms. The paint, quite thickly textured, creates points of great luminous intensity that coincide with the symbolic focuses of the composition.

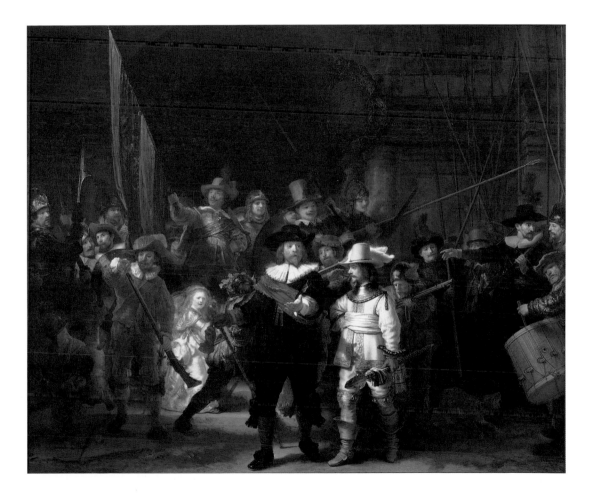

119

Christ and the Adulteress

1644
Oil on panel, 83.8 × 65.4 cm
London, National Gallery
Signed and dated "REMBRANDT
F 1644"

In 1644, with this panel, Rembrandt returned to his style of the early sixteen-thirties, as shown by the elaborate architecture defining the scenic space, for example; the same motif appeared in analogous terms in a panel of 1631, *The Presentation of Jesus in the Temple* (The Hague, Mauritshuis). Such a regression indubitably signals a moment of artistic crisis, but it does not diminish the high quality of this painting: according to Rembrandt's eighteenth-century biographer, Arnold Houbraken, *Christ and the Adulteress* is one of the master's best works.

The episode shown is described in the Gospel of John—a woman caught in adultery was taken to the temple before Jesus for judgment. The Pharisees hoped to test Christ's respect of the Jewish laws, under which she should have been stoned. Christ said nothing, but leaned over to write in the dust, "He who is without sin among you shall throw the first stone." As Rembrandt imagined the scene, it took place inside the temple: against a dark background, above a podium, the great priest reigns from a sumptuous altar surrounded by believers. At the center of the composition, a priest gestures toward the woman whose fate is to be decided; the adulteress kneels below, in tears. Departing from iconographic tradition, Rembrandt does not show the moment when Christ writes in the dust; here, the Messiah is standing and he rises above the crowd. The poses of the Pharisees betray their apprehension and curiosity, and reflect the note that Rembrandt wrote on a drawing: "They were so anxious to catch Jesus in error that they could not wait to hear his answer."

Holy Family with Angels

1645
Oil on canvas, 117 × 91 cm
St. Petersburg, The State
Hermitage Museum
Signed and dated "REMBRANDT
F. 1645"

Over the course of two years (1645–1646) Rembrandt returned to the subject of the Holy Family in at least three paintings. In this one, now in St. Petersburg, he created a quiet composition of a classical appearance, dense with symbolic meaning.

The Holy Family is represented in the woodshop of Joseph, who can be seen working in the background. The Child sleeps in a wicker cradle, watched over by his mother. The Madonna is reading from the Bible and suddenly raises her eyes from the page to turn to her Son. She has just come across a passage on the Savior in the Holy Scriptures, and her gesture underscores her awareness of the Child's destiny; at this revelation, the divine light floods the room and a glory of angels descends from heaven. One angle descends on Mary and Jesus with open arms, a gesture of protection that figuratively seems to foreshadow Christ's death on the cross and his sacrifice for the salvation of humanity. Joseph remains in the shadows, excluded from the message of redemption; he seems intent on his work, which consists in carving a yoke. This element is not just a realistic detail—in the Old Testament prophesy, it is written that the Savior will break the yoke that oppresses the people of Israel.

Young Woman in Bed

c. 1645

Oil on canvas, 81.1 × 67.8 cm
Edinburgh, National Gallery
of Scotland
Signed and dated "REMBRA(...)
F. 164(.)"

The history of this painting is first recorded in 1742, when the Prince of Carignano bought it at a Parisian auction: after various passages, it ended up in a Scottish collection, and in 1892 was bequeathed to the National Gallery in Edinburgh. The conventional title, *Young Woman in Bed*, refers to one of Rembrandt's most controversial works; scholars have proposed contrasting hypotheses about both the iconography and date of this canvas.

According to some interpretations, it is a portrait in costume: given the intimacy of the setting, tradition identifies the woman as Hendrickje Stoffels, the young woman who was Rembrandt's close companion from 1649 on. More recent critics, however, tend to interpret subjects of this kind as history paintings, for which the painter's family members could have posed. If this is the case, the young woman could be Danaë: the few elements describing the setting and the pose invite comparison with the version of this myth in Hermitage, as if the artist had wanted to change perspective and focus his gaze on a detail of the composition. From the Old Testament, on the other hand, this female figure could be Agar awaiting Abraham, or Sarah awaiting Tobias. This second interpretation is supported by the existence of a painting by Lastman that could have inspired Rembrandt; Lastman' s painting, Sarah from her wedding bed, observes the angel Raphael, who struggles with an evil spirit. According to the Biblical story, the maiden had married seven times, but a spirit possessing her had killed all of her husbands; the eighth husband, Tobias, following the advice of the angel Raphael, managed to free her of this evil sorcery.

As for the year this was painted, scholars have swung widely — between 1641 and 1657 — but it is very similar to a *Girl at the Window* of 1645 (London, Dulwich Picture Gallery).

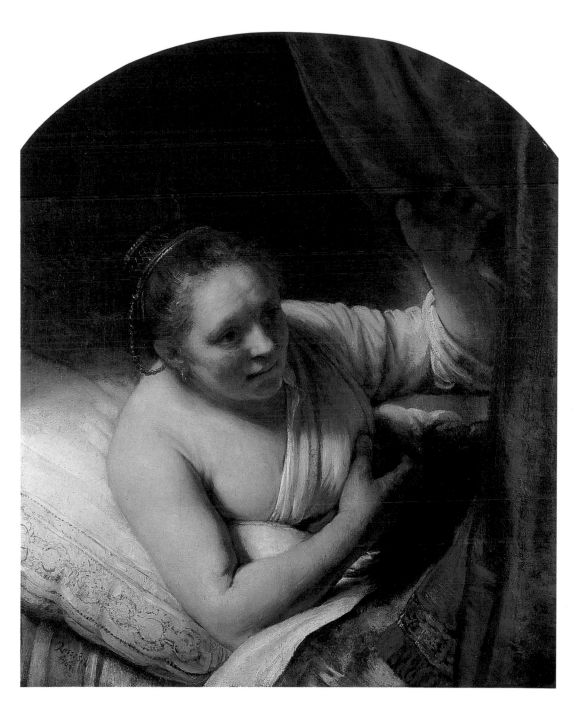

Aristotle with a Bust of Homer

1653
Oil on canvas, 143.5 × 36.5cm
New York, The Metropolitan
Museum of Art
Signed and dated "REMBRANDT
F. 1653"

In 1652 the Italian nobleman Antonio Ruffo di Calabria asked Rembrandt to make a half-length figure of a philosopher for his collection. Two years later, the artist sent him the canvas *Aristotle with a Bust of Homer* (New York, The Metropolitan Museum of Art), which met with full approval of the buyer. The consequent request of two more works as companion pieces to the first gave rise, after a complicated series of events, to *Alexander the Great* and *Homer*, delivered between 1661 and 1664. The small cycle illustrated the figures of the greatest philosopher, greatest poet, and greatest military leader of antiquity. It is highly likely that Rembrandt personally selected the subjects for the three canvases: he certainly had the historical references on which they are based, and in fact they are already expressed in the first painting he did. In it, Aristotle rests his right hand on an antique sculpted bust of Homer, while with his left hand he fondles the gold chain decorating his robe. The jewel has a medallion bearing the portrait of Alexander the Great, who was a pupil of the famous philosopher; from his teacher, the military leader learned to love the work of Homer, praised by Aristotle in his *Poetics*. Thus, the painting of 1653 offers the nucleus of the links between the three historical figures, later developed in successive commissions. As for the symbolic value of this choice of subject, Rembrandt may have wished to illustrate three different aspects of human psychology: discipline (Aristotle), imagination (Homer), and action (Alexander).

In the painting of Aristotle, the philosopher is represented according to the traditional canons regarding portraits of intellectuals and illustrious men: behind him a few books can be seen, and he has surrounded himself with ancient sculptures. The bust of Homer reproduces the features of a known Hellenistic original, perhaps documented in Rembrandt's own collection. The majestic and solemn look, and the introspective, meditative attitude of the philosopher foreshadow *Bathsheba*, painted in 1654.

Young Woman Bathing in a Stream

1654
Oil on panel, 61.8 × 47 cm
London, National Gallery
Signed and dated "REMBRANDT
F 1654"

The problems raised by this painting are very similar to those of the Edinburgh *Young Woman in Bed*: the image, with its intimate and spontaneous atmosphere, has been interpreted variously as a portrait of Hendrickje in costume or as the subject of a sacred story.

In this small panel, a woman wades into the water; gathering the hem of her slip above the water, she proceeds with cautious steps, scrutinizing the streambed. A smile barely hinted at is not owing to her observation of her reflection in the water, as has been suggested, but rather to the pleasant prospect of a bath. If, as some think, the scene is taken from the Holy Scriptures, it could represent Bathsheba's bath; in 1654, Rembrandt also painted the large painting in the Louvre, in which Bathsheba meditates on David's love letter. The two paintings share the element of the brocade robe cast to one side. Conceding that the iconographic interpretation is correct, it should be underscored how the painter gives two different interpretations of the same story: in the small London panel, a negative side of the woman seems to emerge as a malicious seductress. The model for this work may have been an antique statue depicting the *Mulier impudica* (the Immodest Wife), illustrated in an engraving.

In the small space of the painting, Rembrandt moves from the intense shading of the limbs to the impasto technique of the white petticoat; at some points the brownish-yellow ground preparation shows through, while in the stream the paint seems to become as fluid as a watercolor. The use of such a composite technique makes it an extraordinary panel from a stylistic point of view. The small format and spontaneous handling of the color and composition could suggest that it is only a study; however, Rembrandt was not in the habit of making oil sketches for his paintings.

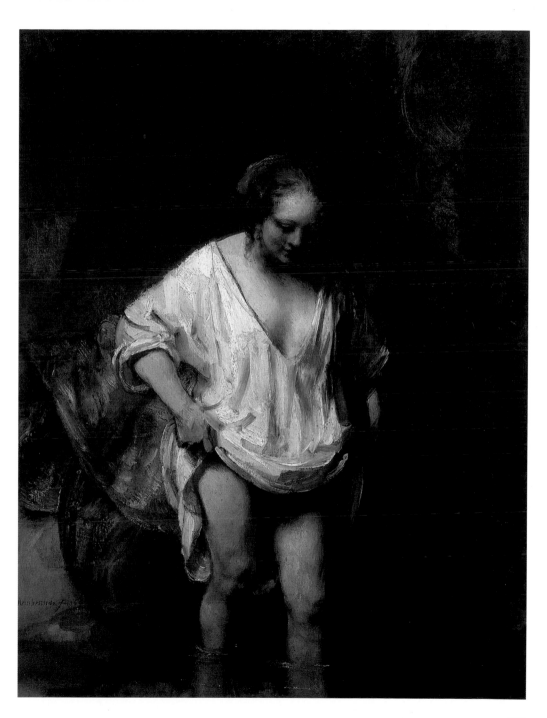

Portrait of Jan Six

1654
Oil on canvas, 112 × 102 cm
Amsterdam, Six Stichting

In *Portrait of Jan Six* Rembrandt shows an extraordinary mastery of technique: the brushstrokes, which at first appear quick and slapdash, are skillfully distributed in an intense and refined weaving of light and shadow.

The painter probably met Jan Six around the mid-sixteen-forties: the young poet came from a rich Huguenot family of fabric manufacturers, and he was a keen scholar and discerning collector. In 1647, Rembrandt portrayed him in a splendid etching where Six is shown in his study, surrounded by books and art objects, intently reading a manuscript. The artist also made the frontispiece for the tragedy *Medea* for him, as well as two drawings for a private album. In 1653, when Rembrandt found himself in financial difficulty, he turned to Six for a loan. When this portrait was made in 1654, the friendly relations between the painter and the refined collector had reached their peak; however, it appears that after this the friendship was broken off. Six, meanwhile, had taken up a career in public office, and for this reason may have believed it unwise to keep his name associated with that of Rembrandt. The artist's social position had, in fact, been undermined by his relationship with Hendrickje, who had been summoned before the church council in 1654.

In the painting, Six appears as a sumptuously dressed gentleman who nonchalantly holds in one hand the glove he has just removed. One suggestive interpretation states that the technique Rembrandt deployed in this picture would be the translation in pictorial terms of *sprezzatura* (disdain): this is the term Baldassar Castiglione used in *Il Cortegiano* (*The Courtier*) to describe the quintessential comportment of the aristocrat, who must demonstrate comfort and effortless conduct in every situation.

131

Bathsheba with the Letter from King David

1654
Oil on canvas, 142 × 142 cm
Paris, Musée du Louvre
Signed and dated "REMBRANDT
F. 1654"

The early history of this *Bathsheba* is not known, but over the course of the nineteenth century it was put up for sale several times. In 1869, thanks to a bequest, the Louvre came into possession of what by all rights may be considered one of Rembrandt's finest works. The painting shows the opening of the biblical story of Bathsheba, Uriah's wife. One evening King David saw her when she was bathing, and, sending messengers to summon her, made her his lover. Upon her husband's death in battle, the woman (who carried David's child in her womb) went into mourning, and when the prescribed period was over, she and the king married. In Rembrandt's version of the story, he eliminated all the extraneous narrative elements called for in iconographic tradition: neither the king nor the messenger appears, and the only trace of David is in the love letter the woman holds open in her right hand. Her absorbed gaze suggests the interior struggle she feels between fidelity to her husband and obedience to the king. The later development of the story is foreshadowed here, and depends solely upon her choice.

The figure of the woman, life-sized and nude, occupies much of the picture. She sits near the tub on a bench with a rich brocade cover and a candid white gown, and at her feet can be made out the figure of an old handmaiden. The color and light are managed with classical severity: in the golden tones of Bathsheba's flesh echoes of Venetian painting may be seen. Many elements of the composition declare Rembrandt's familiarity with a classical bas-relief reproduced in an engraving of 1645; the image's static feeling and the compositional rigor come from the same source. The majestic character and statuary look of the figure are qualities it shares with *Aristotle with a Bust of Homer* painted one year before.

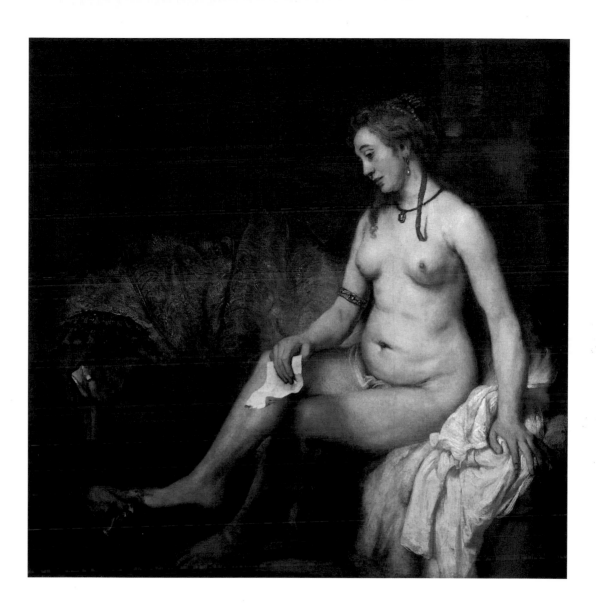

Henrickje Dressed as Flora

c. 1654
Oil on canvas, 100 × 91.8 cm
New York, The Metropolitan
Museum of Art

As already seen in two paintings of the mid-sixteen-thirties, Rembrandt returns here to the theme of Flora. The tradition that identifies the woman portrayed as Hendrickje Stoffels is not supported by the existence of an ascertained portrait.

In this canvas, which has lost the baroque exuberance of the two previous ones, Flora is shown with her head in profile, but her bust is parallel to the surface of the painting; the woman holds out flowers in her right hand, while her left gathers up the hem of her skirt. The dress is composed of a yellow skirt and a simple white blouse that bunches up at the arms in puffy folds; the black hat is decorated with sprigs of cherries. Her ruddy face is described with delicate tones. Many elements connect Rembrandt's pictorial invention to Titian's *Flora* now at the Uffizi: the overall layout, the handling of the white blouse, the hands holding out the flowers, and the hem of the dress. Around 1641 Titian's painting was in Amsterdam, in Alfonso López's collection, where Rembrandt also had the opportunity to see his *Ariosto*. Titian's influence is also obvious in *Portrait of Saskia*, from 1641, now in Dresden: the artist's wife is shown as she presents a carnation, while with her left hand she clutches a transparent shawl over her bodice.

The approximate date of 1654, which not all critics are willing to accept, is based on a comparison with two works of these same years, *Aristotle with a Bust of Homer* and *Bathsheba*. Common to all three paintings is the sense of solemn calm that derives from the handling of the composition in parallel planes, and the attitudes of the figures, who are introspective and majestic in their simplicity. According to some scholars, the model who posed as Flora and Bathsheba are the same person; leaving aside the question of her identity, the positions of the two figures are the same, with the face in profile and the bust seen frontally.

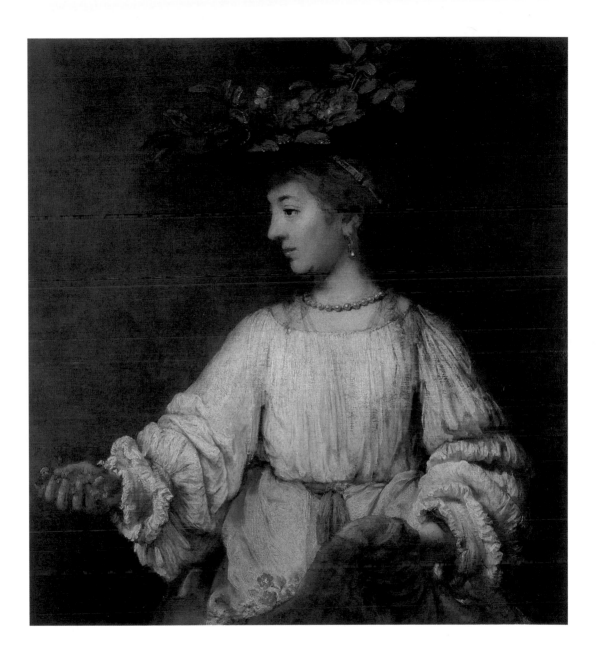

135

Alexander the Great (or Athena)

c. 1655
Oil on canvas, 118 × 91 cm
Lisbon, Museu Calouste
Gulbenkian

The critics are divided about whether or not this painting should be seen in relation to the patronage of Antonio Ruffo di Calabria, who in 1654 asked Rembrandt for two half-length figures as companion pieces to *Aristotle with a Bust of Homer*. When the painter's messy bankruptcy proceedings were over, the works requested arrived in Messina in 1661. The pieces were *Homer* and *Alexander the Great*, and the patron rejected them both. Ruffo complained that the figure of the military leader had been done on a patched canvas, and that the seams were evident. In light of this information, *Alexander the Great* can be identified as a painting now in Glasgow which shows a half-figure with armor, helmet, shield, and a red mantle; the support shows on the sides the addition of four strips of canvas. From an iconographic point of view, the Scottish painting shows clear similarities with this one in Lisbon, which looks like an alternative version of the same subject. Bearing these considerations in mind, it is not unreasonable to think that Rembrandt sent the Portuguese painting to Messina to replace the rejected one, if the painter had ever provided for such a settlement. However, a series of questions remain open. First of all, the attribution to Rembrandt is not unanimous: the pictorial quality is uneven, and we must presume that a pupil contributed to at least some of the work. Moreover, it is not certain whether the person depicted is Alexander; the iconography of the Greek *condottiere* is, in fact, very similar to that of Athena, and the attributes shown in the painting do not solve the problem. If the subject were mythological, any link to Ruffo's commission would have to be excluded. The date of the painting's execution is based, for want of other data, on stylistic and iconographic similarities with the version of *Alexander the Great* in Glasgow, which bears the painter's signature and the date 1653. Here, too, there is no dearth of doubts, since it is known that Rembrandt did not send any paintings to Ruffo until 1661.

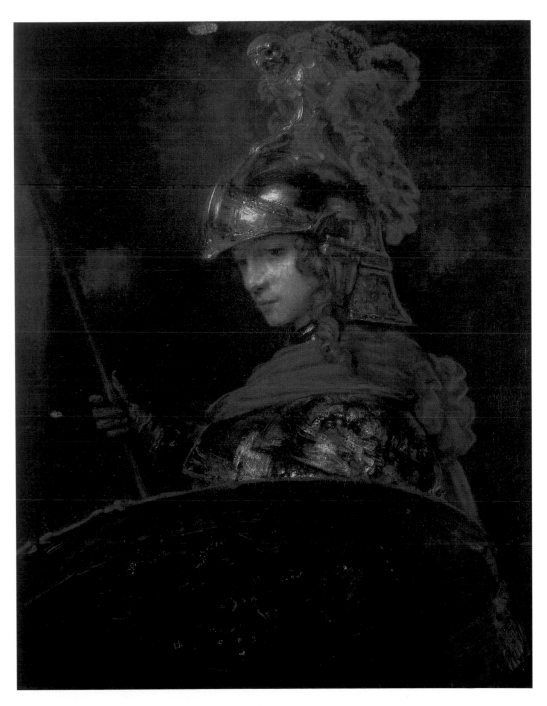

The Polish Rider

c. 1655
Oil on canvas,
116.8 × 134.9 cm
New York, The Frick
Collection
Traces of signature "RE"
(damaged)

The title traditionally used to refer to this work reflects only a part of the number and variety of interpretations that have been proposed for it. It is not clear whether it is a historical subject, portrait, genre image, or allegorical scene.

In the painting an armed horseman is shown dressed in clothing of a Near-Eastern style; the man marches through a gloomy landscape dominated by a city in the distance. The face does not appear particularly characterized or finished, and therefore we can exclude that Rembrandt wished to portray a person he knew. To the contrary, the face seems that of an idealized hero, which has led to the hypothesis that the horseman is the mythical founder of Amsterdam, Gijsbert, or again an allegorical depiction of the *miles christianus*, defender of the faith and the West. It is not even certain whether in the intentions of the painter, the costume and tack had anything to do with Poland at all. However, ever since the painting appeared in a Polish collection, there has been an effort to demonstrate that the person depicted is Polish, perhaps even a Socinian heretic present in Amsterdam in 1654. In any case, the man's attire seems in line with the kind of Near-Eastern costume Rembrandt used for his figures in holy scenes. Some studies, therefore, lean toward a biblical interpretation of the figure, identifying the person as David preparing for battle.

Despite some doubts concerning the attribution, *The Polish Rider* is one of Rembrandt's most famous paintings: the painterly handling and compositional features show the same qualities as the great works from the years around 1655, such as *Bathsheba* and *Aristotle*.

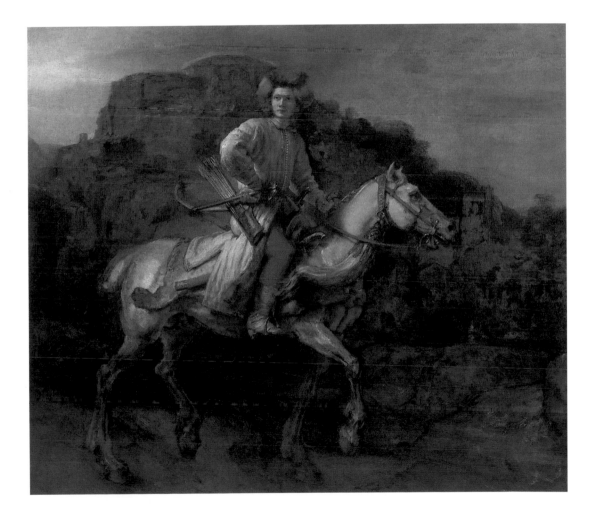

139

The Slaughtered Ox

1655
Oil on panel, 94 × 69 cm
Paris, Musée du Louvre
Signed and dated "REMBRANDT
F. 1655"

After painting this panel, Rembrandt kept it in his studio until it was sold at auction: it may even be possible to identify the painting among the list of assets drawn up in 1656 in preparation for their sale. A signed variation on the work also exists, now at the Glasgow Art Gallery; scholars believe that it is a copy made by a pupil.

In Dutch genre painting the depiction of dead and butchered animals was frequent in kitchen scenes, and became widespread around the mid-sixteenth century. Before *Slaughtered Ox*, Rembrandt had included this theme in two youthful works, *Girl with Dead Peacocks* and *Self-Portrait with Bittern*. Compared to the two paintings of 1639, this one shows a reconsideration of the role of the human figure, which is now reduced to an absolutely minor importance. A woman peering through a doorway can be glimpsed in the background, but the painter's attention is fully focused on the ox: the animal's carcass is in the foreground and described in crudely realistic terms. The paint is thick and textured, and the uneven handling of the painted surface suggests the very quality of meat, which the light strikes, projecting real shadows; thick red enamels that seem to drip down the panel render the idea of clotted blood. For these features of expressive realism, *The Slaughtered Ox* has been taken up and copied by such modern painters as Eugène Delacroix and Chaïm Soutine.

As with Rembrandt's earlier still lifes, critics have proposed a symbolic reading: in genre painting, the presence of the slaughtered animal alluded to the theme of *Prudentia*, or prudence, a virtue that indicates the ability to prepare for future needs, anticipating what could be useful for confronting them. It is hard to say if the painter wanted, with this, to allude to his own serious financial problems, which the following year led him to declare bankruptcy.

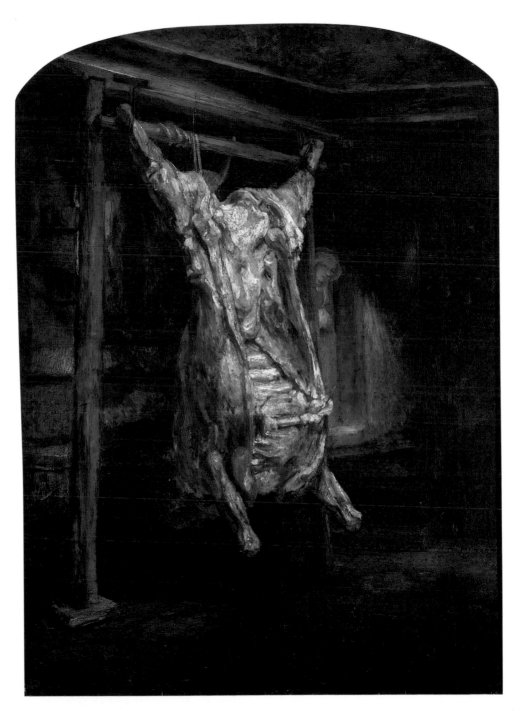

141

The Anatomy Lesson of Dr. Deyman

1656
Oil on canvas, 100 × 134 cm
Amsterdam, Rijksmuseum
Signed and dated "REMBRANDT
F. 1656"

In 1656 Rembrandt received a commission from the surgical guild of Amsterdam, which requested a group portrait of its most illustrious members. The painting was to be hung in the city's anatomical theater, already the home of *The Anatomy Lesson of Dr. Tulp*, painted by the artist in 1632. In 1690 the theater was dismantled and the painting was moved to the new guild headquarters. Here, in 1723, a fire destroyed much of the canvas, of which only a fragment remains. In 1841, *The Anatomy Lesson of Dr. Deyman* was sold at an auction for the benefit of surgeons' widows; after passing into various private English collections, the work was purchased by the city of Amsterdam in 1882. Before the fire, the painting measured about 275 x 200 centimeters; what is left today is the central portion of the lower area, in which Gysbrecht Calcoen, guild master, can be seen taking part in the dissection of a corpse. Of the main figure of the scene, the *praelector anatomiae* Jan Deyman, only the torso and the hands can be seen, busy with the dissection of the brain. A drawing by Rembrandt documents what was lost: around the main group were seven other figures, positioned as observers around a circular tribune beneath two arches. Compared to the 1632 painting, this interpretation of the anatomy lesson is closer to the tradition of the genre: the leading figure is at the center, and as far as the drawing shows the others are arranged in a semi-circle to his back, with their gaze turned outside the painting. The most original element of the composition is the cadaver's position, seen frontally by the observer: the foreshortening, plank table, and detail of the feet in the foreground are, according to many scholars, a citation of Andrea Mantegna's *Dead Christ*. After Mantegna, however, a number of other artists returned to the motif; among others, Orazio Borgianni made both a painting (1615) and an engraving, which Rembrandt may have seen.

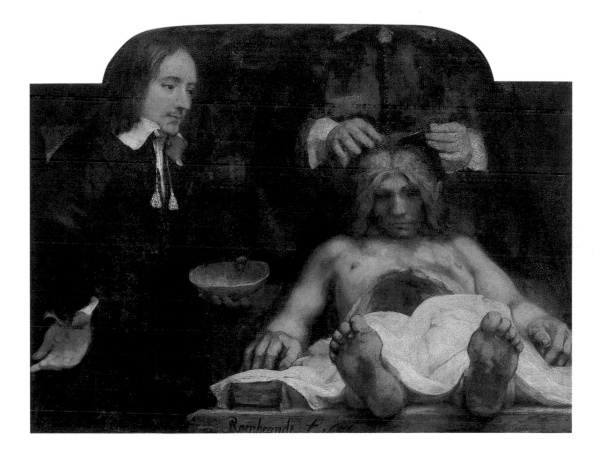

Self-Portrait with Staff

1658
Oil on canvas, 133.7 × 103.8 cm
New York, The Frick
Collection
Signed and dated "REMBRANDT
F. 1658"

Among Rembrandt's many suggestive self-portraits done in old age, this one proposes the painter in royal clothing and pose. There are no certain elements for understanding whether the painter meant to portray himself in the attire of precise historical or mythical figures: in the course of his lifetime, he often depicted himself with fanciful court costumes. Compared to the youthful works, there is a striking note of melancholy, obvious in the shadow that veils the artist's gaze: this mood recurs in several self-portraits of the final period, and scholars never fail to trace it back to the tragic events that marked Rembrandt's life from 1656 on.

A recent study has suggested that this painting was created together with a *Juno* companion piece, presently in the Hammer collection in Los Angeles, in which Hendrickje's Stoffel's features have been recognized. Such a link would give credence to the idea that this self-portrait is a figure of Jupiter.

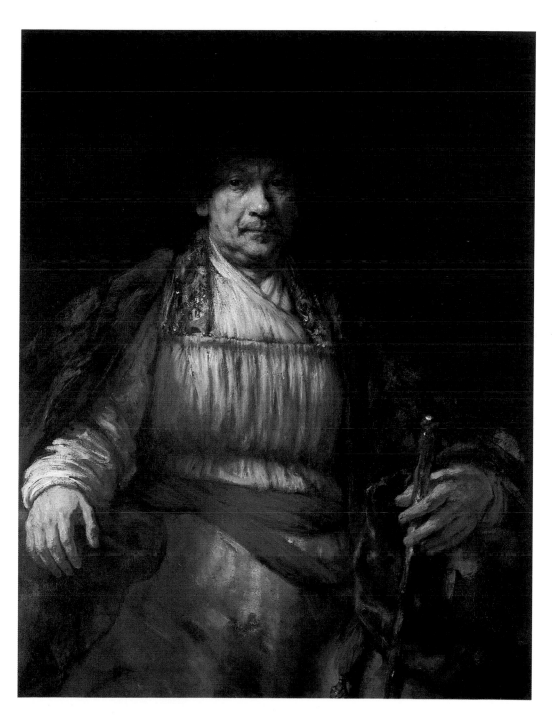

Moses with the Tablets of the Law

1659
Oil on canvas, 168.5 × 136.5 cm
Berlin, Staatliche Museen
zu Berlin, Preußischer
Kulturbesitz, Gemäldegalerie
Signed and dated "REMBRANDT
F. 1659"

It is thought that this canvas was prepared for the decoration of the Amsterdam town hall, a project to which various artists contributed, starting in 1659. The patrons rejected Rembrandt's painting and replaced it with one by Ferdinand Bol on the same subject, which remains there today. This hypothesis is not supported by the scarce certain data available, recorded in 1764 and documenting the *Moses* in the collection of Frederick the Great at Potsdam in the Sansouci castle.

Interpretation of the iconography also poses problems, since the painting could illustrate two different moments described in the Book of Exodus. In the first, Moses descended Mount Sinai with the stone tablets of the law, but seeing the people of Israel worshiping the golden calf, he flew into a rage and smashed them. Then Moses went back up the mountain and received a second set of the Commandments; as he showed his people the new tablets, his face shone with the enlightenment he had received from God. The ambiguity arises from Rembrandt's decision to remove the figure of the patriarch from the narrative context. Moses's gesture and the rock to his left suggest that the scene is the smashing of the tablets; however, the figure's stance is similar to that of rabbis during the religious service when they display the parchment of the Torah. The painter's knowledge of the Hebrew world is demonstrated, among other things, by the precision with which the last five commandments are transcribed in the picture. The intense light illuminating Moses's face has also been much discussed; it is probably a naturalistic rendering of the radiance caused by the vision of God. The Hebrew word for "radiant" also means "horned," and for this reason, in the iconographic tradition, horns are a recurrent attribute of Moses's holiness. In the painting, this element appears in the form of two curls growing from the patriarch's forehead.

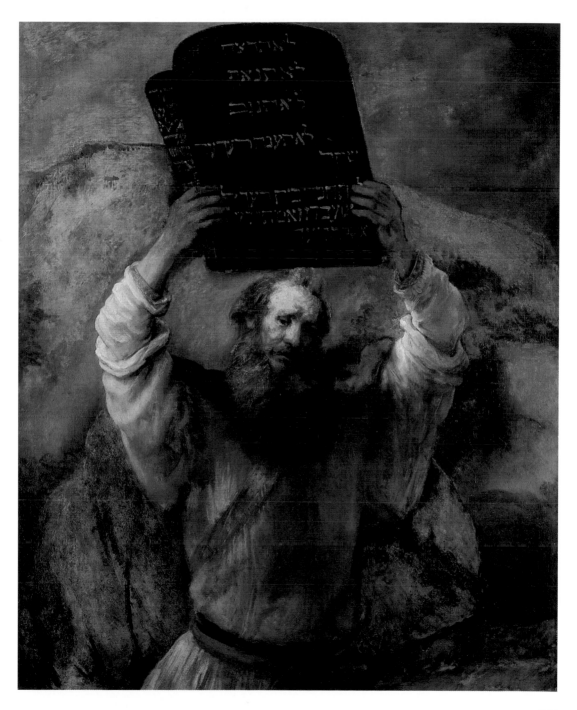

147

Titus Dressed as Saint Francis

1660
Oil on canvas, 79.5 × 67.5 cm
Amsterdam, Rijksmuseum
Signed and dated "REMBRANDT
F. 166(0)"

Rembrandt made several portraits of Titus in his paintings and etchings, especially when the boy was young: therefore, there are no doubts about the identity of the youth who posed for this canvas, which was done when the artist's son was nineteen years old. The significance of the painting, on the other hand, is controversial; once again, as in many of Rembrandt's works, critics have noticed an intrinsic ambiguity. It is impossible to establish whether this is a portrait in costume or a historical figure modeled on a real person closely acquainted with the artist. Scholars do not even agree about the identity of the person depicted: according to some, he is Saint Francis, while for others he is simply a monk. This subject recurs in two other paintings by Rembrandt from around 1660, and they pose similar problems of interpretation.

The image has a moody atmosphere; the practically monochrome palette and the sketchy manner are typical of the master's late work.

Peter's Denial of Christ

1660
Oil on canvas, 154 × 169 cm
Amsterdam, Rijksmuseum
Signed and dated "REMBRANDT
1660"

In *Peter's Denial of Christ* Rembrandt took his inspiration from the Utrecht Caravaggesques, who had been an important point of reference in his early work.

This painting shows an episode recounted in the Gospel: right after Christ's capture, the apostle Peter was recognized by a servant and a guard outside the Sanhedrin. At the woman's question, he denies being a follower of Jesus, and this is one of the three denials prophesied by the Messiah: "This night, before the cock crows, thou shalt deny me thrice...". Peter's head is wrapped in a heavy mantle, as if to hide or protect himself from the cold, and his face is illuminated by candlelight: the servant, in fact, holds a light up to him to be sure she had recognized him. Hearing the conversation between the two, the soldier in the foreground raises his head and looks at the apostle with clear distrust. As in the Gospel, the figure of Christ captured in the background turns to look at Peter.

The theme of light dominates the painting: the device of the artificial light within the painting, derived from Caravaggio, allows the artist to heighten the colors in sudden flashes, similar to what occurs in *The Conspiracy of Julius Civilis*, painted in 1661–1662.

The Conspiracy of Julius Civilis
(The Batavian Oath)

1661–1662
Oil on canvas, 196 × 309 cm
Stockholm, National Museum
of Fine Arts

In 1660, when Rembrandt was commissioned to paint a canvas for the decoration of the Amsterdam Town Hall, he did a very large work (over 5 x 5 meters), which two years later appears to have already been mounted in its place. Later, however, the buyers rejected it for unknown reasons, and returned it to the painter; the next mention we have of it dates from the eighteenth century, when it was in circulation on the antiquities market. The present dimensions of the canvas were obtained by cropping off large sections; it is believed that Rembrandt himself was responsible for this, in hopes to better adapt it for sale on the market.

The commission was for the illustration of an episode from the Dutch national history, the oath in the first century A.D. that ratified the rebellion against the Romans. The event was seen to have analogies with the revolt led by William of Orange against Spain. Closely following the story according to the original sources, Rembrandt shows the barbarian tribal chiefs in the ritual act of crossing swords: in imagining the gestures, attire, and decorations, the painter diverged from the classical canons that the Dutch favored when depicting their forebears. It may have been a question of decorum that led to the painting's removal from the town hall: in the lighting and the arrangement of the figures, the scene recalls the Dutch Caravaggesque's tavern scenes, and the hero Julius Civilis is depicted as a one-eyed old man. The leader of the Batavians was, in fact, blind in one eye, but the other painters involved in the town hall project had been careful always to show him in profile. It may also be that the buyers' disapproval had to do with Rembrandt's painting style, typical of his later work; the intense drama of the scene is rendered in large, practically monochrome color fields, synthetic, barely sketched-out forms, and pigments applied in thick impastos.

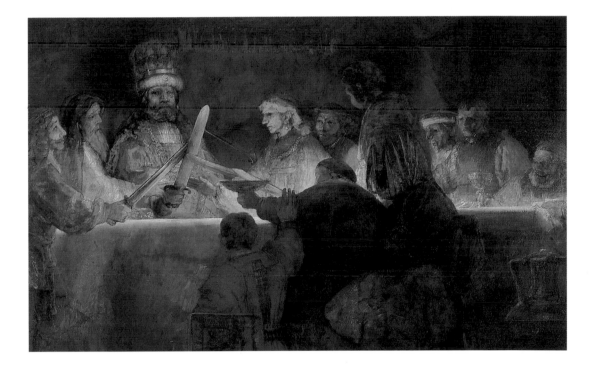

The Syndics of the Drapers' Guild

1662
Oil on canvas, 191.5 × 279 cm
Amsterdam, Rijksmuseum
Signed and dated "REMBRANDT
F. 1662" (on the tapestry
covering the table); apocryphal
signature "REMBRANDT F. 1661"
(on the wall to the upper right)

This painting shows the members of a commission of the Drapers' Guild charged with checking the quality of fabrics manufactured and sold in Amsterdam. Together with five other paintings illustrating the same subject, this one remained in the guild headquarters until 1778, when it was moved to the Amsterdam town hall. In 1808 it was given on loan to the nascent Rijksmuseum.

The individuals depicted in the painting have been recognized with a fair degree of certainty; there is a list of the syndics in office in 1661–1662, who were then identified among the figures on the basis of age and social position. The man seated at the center before an open book is the president of the syndics, Willem van Doyenbourg, surrounded by his associates. The standing figure, in the middle ground, is Frans Bel, the servant who lived in the guild palace and saw to its upkeep. The buyers had imposed on Rembrandt the traditional presence of this figure; in previous portraits, the servant had always appeared among the drapers' guild syndics. The insertion of Bel evidently created compositional problems for Rembrandt, since x-ray analysis of the painting shows that the artist changed placement of the figure several times. The artist also had second thoughts about the second figure from the left, who in the final version is shown in the act of rising from his chair. This position, which Rembrandt used to develop the composition, gave rise to the unfounded idea that the syndics were portrayed at the close of a meeting, surprised by an unforeseen event. In the wainscoting in the background, Rembrandt introduced a barely visible panel with a lighthouse lit up by the signal fires: it was a symbolic allusion to the role of the persons represented, who had to steer a course of responsibility in trade.

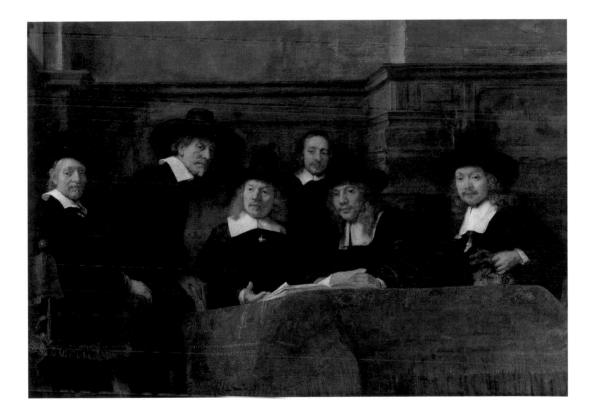

155

Suicide of Lucretia

1664
Oil on canvas, 120 × 101 cm
Washington, National Gallery of Art
Signed and dated "REMBRANDT F 1664"

Rembrandt approached the subject of the death of Lucretia in three different works, one of which has been lost. The painter may have taken inspiration for his paintings from Italian models, as there are versions of the subject by Titian and by Marcantonio Raimondi in famous engravings. Livy writes about the story of Lucreti the virtuous Roman matron, wife of Collatinus, who rejected the amorous advances of Sextus Tarquinius. Sextus, who was the son of King Tarquin the Proud, threatened to kill her and place her corpse next to that of a servant, so that she would appear guilty of adultery. Lucretia then yielded to his demands. The following day she told her father and husband what had happened, asking for revenge; then, preferring death to dishonor, she committed suicide. In this picture, Rembrandt shows the moment when she is poised to plunge the dagger into her breast, a gesture of the left hand and her parted lips suggesting the last, desperate words. In a later painting (1666, Minneapolis, Minneapolis Institute of Arts), he showed her dying, with blood spreading over her dress.

Critics have given various assessments of this *Suicide of Lucretia*: for example, Hendrickje Stoffels's features have been recognized in the woman's face, inducing some to regard the picture as the painter's homage to the woman who had died one year earlier and had also been accused of immoral conduct. There is also a political interpretation of the artist's interest in the subject: in Rome, Lucretia's death gave rise to a popular rebellion that led to the dethroning of the king and the proclamation of the republic.

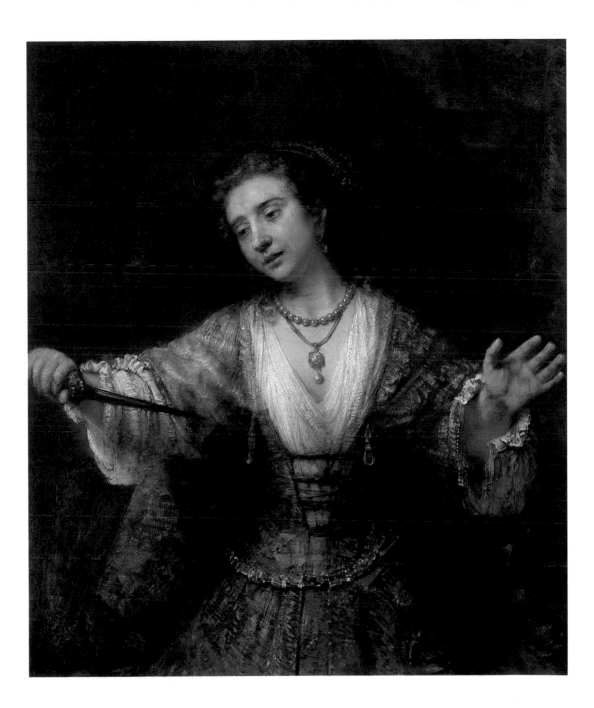

Self-Portrait with Palette and Brushes

c. 1665
Oil on canvas, 114.3 × 94 cm
London, Kenwood House

Among the many self-portraits done at an advanced age, this one shows Rembrandt as a painter in his studio. The artist wears his work clothes and holds in his left hand the palette, brushes, and palette knife; only the edge of the canvas he has before himself can be made out, in the top right corner. In a prior version, ascertained through x-ray analysis, Rembrandt had shown himself in the act of painting, with his left hand raised toward the canvas.

In the background hangs a canvas dominated by two semi-circles: this element has given rise to various interpretations of a symbolic nature, none of which, however, is entirely convincing. Cabalistic symbols, and images of divine perfection according to some, the circles have also been interpreted as a reference to the role of the artist: they could demonstrate skill in freehand drawing, or bring to mind a complex reflection on the relationship between theory, practice, and innate talent. Seen in the context of iconographic tradition, they look like a stylization of the world maps that often appeared in Dutch paintings depicting painters' studios: here again, we cannot exclude an allusion to the universality of art and its role as a mirror of the visible world. Nor can we exclude that in painting these circles, Rembrandt simply wanted to develop a purely formal motif, combining the curved lines of the backdrop with the straight lines of the figure. Analysis of Rembrandt's facial features and study of the painting technique suggest a dating around the mid-sixties, when his style was evolving toward an increasingly free and highly textured approach. In the canvas, there are a few unfinished areas and an abundant use of white lead applied in thick strokes. The eyes, as in other late works, were painted with thin varnish over eye sockets left empty during the first phase of painting.

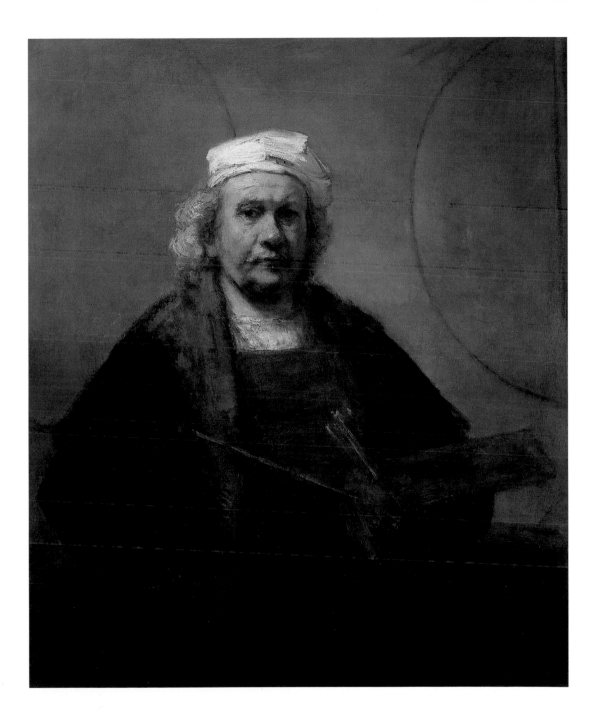

Isaac and Rebecca
(The Jewish Bride)

c. 1666

Oil on canvas, 121.5 × 166.5 cm
Amsterdam, Rijksmuseum
Signed and dated "REMBRANDT
F 16(..)"

As with many figures Rembrandt painted, it is not clear whether this painting should be seen as a portrait in costume or a historical scene for which the painter used models from life. What is certain, though, is that the title traditionally used to refer to this work (_The Jewish Bride_) is misleading: it reflects the old belief that the individuals shown are a Jewish father and his daughter, and the embrace that the two exchange is a gesture of farewell for her immanent marriage. In the painting, the man wraps his left arm around the woman's shoulder, while he rests his right hand on her breast; she responds to the caress with a light touch of the hand. The intimacy of these gestures clearly does not indicate a paternal relationship, and the current opinion is that the picture therefore shows a husband and wife.

Comparison of _The Jewish Bride_ with a drawing by Rembrandt has made it possible to identify with certainty the iconographic model for this composition: in the drawing there are two figures posed as in the painting, and behind them is a person observing them unseen. The subject is taken from the Old Testament: the man spying is Abimelech, who thus discovers the bond between Isaac and Rebecca. He thought that the two were brother and sister, because that is what Isaac himself had said, fearing that someone would kill him because of his relationship with her. The unquestionable formal relationship of the painting with the drawing sheds some light on the meaning of the work, but not the nature of the painting, which remains suspended between the portrait in biblical costumes and the holy scene.

From a stylistic point of view, the monumental frontal perspective of the figures, the Venetian style of light, the thick application of the paint, and the harmony of just a few main colors are typical of the artist's later years.

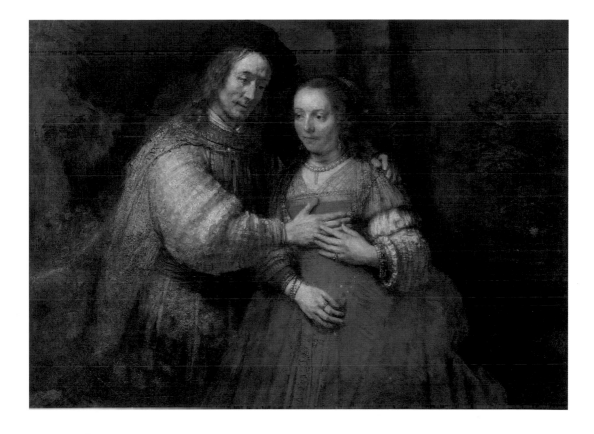

The Return of the Prodigal Son

c. 1666
Oil on canvas, 262 × 206 cm
St. Petersburg, The State
Hermitage Museum
Inscription "RF RYNF"
(added later)

The Return of the Prodigal Son is commonly held to be one of the most moving paintings of Rembrandt's late period; the fact that for many scholars the contribution of an assistant can be discerned in no way diminishes its quality, which clearly derives from the painter's initial idea.

This painting shows the final moment of the parable of the prodigal son: on the threshold of the house, the father takes in his repentant son with a gesture of welcome and pardon. Some other figures witness the scene: the standing man in the foreground has been identified as the elder brother, while the seated man pounding his breast and the women who can be made out in the background seem to have the simple function of onlookers. It appears that the contribution of Rembrandt's pupil, perhaps Aert de Gelder, is mainly focused on these minor figures.

Rembrandt may have drawn inspiration this painting from an engraving by the Dutch artist Maarten van Heemskerck, though with some important modifications. In his version of the theme, he altered the viewer's perspective, making it coincide with that of the prodigal son; the imploring son buries himself in the arms of his father, who clasps the young man's shoulders with a gesture of tenderness and pity. The youth wears worn-out clothes, torn and full of holes, and his blistered feet poke out from worn sandals. Using colors, the painter enclosed the two in a single, harmonious form composed of the son's tunic and the father's robe; with the bright red of the mantle, he underscores the gesture of the embrace. The precise year of this painting is rather controversial; the palette and formal and compositional choices clearly associate it with other works of the later years, such as *The Jewish Bride* and *Family Portrait*.

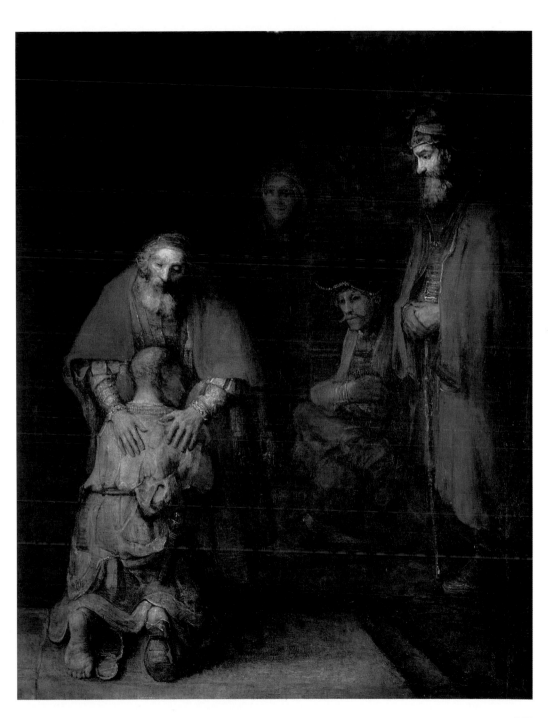

Family Portrait

c. 1668
Oil on canvas, 126 × 167 cm
Braunschweig, Herzog Anton
Ulrich-Museum
Signed "REMBRANDT F"

When Count Anton Ulrich von Braunschweig purchased this painting, it was thought that the individuals portrayed were Rembrandt with his wife and children; obviously, such an interpretation is unfounded. The present state of studies, however, has not shed light on the identity of the persons shown. The hypothesis that the woman is Titus's wife, Magdalena van Loo, shown together with her brother-in-law François van Bylert and his children, also seems improbable.

The painting shows features typical of the painter's late work, already revealed in the painting known as *The Jewish Bride*: the figures are shown half-length on a horizontal plane and the colors are limited to just a few shades, among which red is predominant. The pigment is spread over the canvas in rich, thick brushstrokes, using an uneven impasto; the details of the clothing are worked in relief so that they capture the light and cast real shadows over the painting's surface.

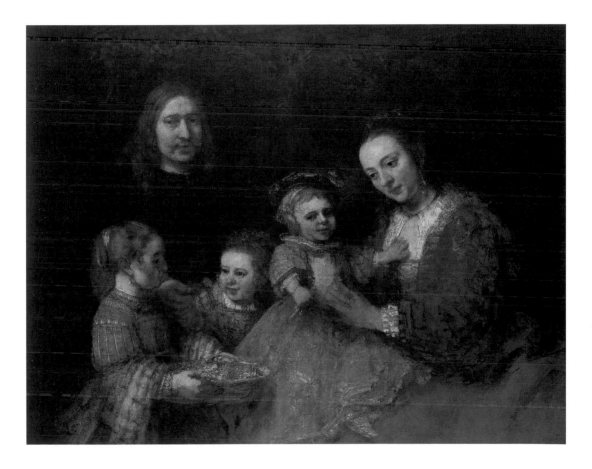

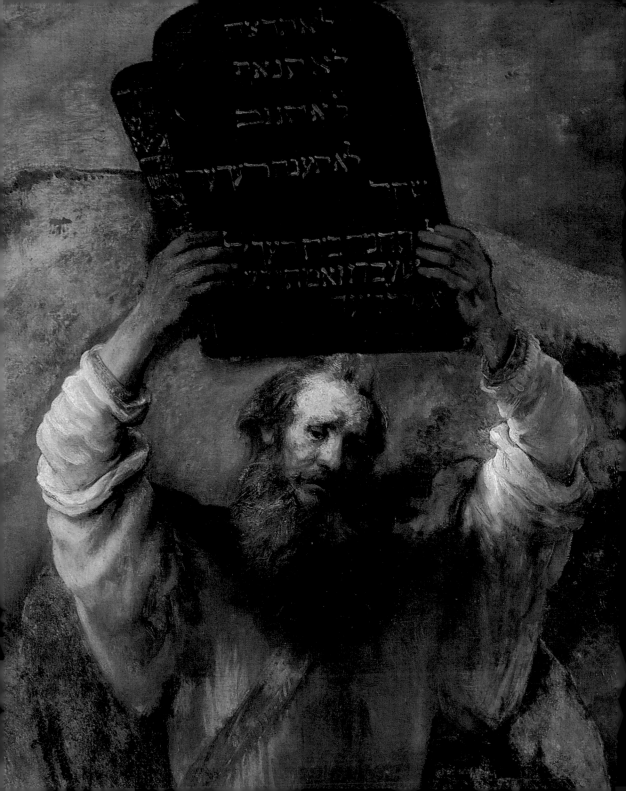

Appendix

Moses with the Tablets of the Law
(detail), 1659
Berlin, Staatliche Museen zu
Berlin, Preußischer Kulturbesitz,
Gemäldegalerie

Chronological table

	Life of Rembrandt	Historical and Artistic Events
1606	Rembrandt Harmenszoon van Rijn is born on July 15 in Leiden.	Caravaggio paints Death of the Virgin.
1621	He starts his apprenticeship with Jacob van Swaneburgh.	Rubens begins the Marie de Médicis cycle. Van Dyck arrives in Italy.
1624	Rembrandt is in Amsterdam in the studio of Pieter Lastman.	In France, construction is started on the royal palace of Versailles.
1625	Rembrandt settles in Leiden as an independent painter, and he signs his first dated work; his partnership with Jan Lievens begins..	Maurice Prince of Orange dies and is succeeded by Frederick Henry as *stadhouder*.
1628	Gerrit Dou enters Rembrandt's workshop as pupil; the artist makes his first dated etchings.	
1631	Rembrandt starts his own activity in Amsterdam, in association with Hendrick Uylenburgh.	
1634	Rembrandt marries Saskia; he becomes a citizen of Amsterdam and member of the painters' guild.	Francesco Borromini designs the church of San Carlo alle Quattro Fontane.
1639	Rembrandt moves to a new house that reflects the level of social prestige he had achieved.	In Rome, Pietro da Cortona paints the affresco in the vault of Palazzo Barberini.
1641	His son Titus is born.	Anthony van Dyck dies in London.
1642	Saskia dies. Geertje Dircks joins the Rembrandt household as Titus's nurse. Rembrandt signs *The Night Watch*.	
1647	Rembrandt hires Hendrickje Stoffels as governess.	*Stadhouder* Frederick Henry dies and is succeeded by his son William II.
1648		End of the Thirty Years' War between Spain and Holland: recognition of the Dutch Republic of the United Provinces.
1650	Two experts sent by creditors assess the painter's assets. Sicilian nobleman Antonio Ruffo commissions a painting from Rembrandt.	After the death of William II, forces opposed to the House of Orange prevail; Holland remains without a stadhouder until 1672.

Life of Rembrandt	Historical and Artistic Events	
1652	Cromwell's Navigation Act sparks the outbreak of the first Anglo-Dutch War	
1654	Hendrickje is tried before the church council for immoral conduct. Cornelia, the painter's illegitimate daughter, is born.	
1656	Declaration of bankruptcy and inventory of goods drawn up in view of the auctions of 1657–1658.	Jan Vermeer paints *The Procuress*.
1662	*The Conspiracy of Julius Civilis* is hung in the town hall gallery, but will soon be returned to the painter.	
1663	Hendrickje dies.	
1667	Cosimo III de' Medici visits Rembrandt's studio.	Conclusion of the second Anglo-Dutch War.
1668	Titus dies.	Vermeer paints *The Astronomer*.
1669	On October 4, Rembrandt dies.	In Rome, Pietro da Cortona dies.

Geographical Locations of the Paintings

in public collections

France

Bathsheba with the Letter
from King David
Oil on canvas,
142 x 142 cm
Paris, Musée du Louvre
1654

The Slaughtered Ox
Oil on panel,
94 x 69 cm
Paris, Musée du Louvre
1655

Germany

Diana Bathing with Her
Nymphs and Stories of
Actaeon and Callisto
Oil on canvas, 73.5 x 93.5 cm
Anholt, Museum Wasserburg
Anholt
1634

Rape of Proserpine
Oil on panel,
84.5 x 79.5 cm
Berlin, Staatliche Museen,
Gemäldegalerie
c. 1632

Portrait of Cornelis
Claeszoon Anslo and His
Wife Aaltje Schouten
Oil on canvas,
176 x 210 cm
Berlin, Staatliche Museen,
Gemäldegalerie 1641

Moses with the Tablets
of the Law
Oil on canvas,
168.5 x 136.5 cm
Berlin, Staatliche Museen,
Gemäldegalerie
1659

Family Portrait
Oil on canvas,
cm 126 x 167
Braunschweig, Herzog
Anton Ulrich-Museum
c. 1668

Rape of Ganymede
Oil on canvas,
177 x 130 cm
Dresden, Staatliche
Kunstsammlungen,
Gemäldegalerie 1635

The Happy Couple
Oil on canvas,
161 x 131 cm
Dresda, Staatliche
Kunstsammlungen,
Gemäldegalerie,
c. 1636

Deposition from the Cross
Oil on panel,
89.4 x 65.2 cm
Munich, Alte Pinakothek
c. 1633

Germany		*Holy Family* Oil on canvas, 183.5 x 123.5 cm Munich, Alte Pinakothek *c.* 1635	

Great Britain

Young Woman in Be
Oil on canvas,
81.1 x 67.8 cm
Edinburgh, National Gallery
of Scotland
c. 1645

Saskia Dressed as Flora
Oil on canvas,
123.5 x 97.5 cm
London, National Gallery
c. 1635

Belshazzar's Feast
Oil on canvas,
167.6 x 209.2 cm
London, National Gallery
c. 1636

*Self-Portrait with
Embroidered Shirt*
Oil on canvas, 93 x 80 cm
London, National Gallery
1640

Portrait of Agatha Bas
Oil on canvas,
105.2 x 83.9 cm
London, Buckingham
Palace, Royal Collections
1641

Christ and the Adulteress
Oil on panel,
83.8 x 65.4 cm
London, National Gallery
1644

*Young Woman Bathing in a
Stream*
Oil on panel, 61.8 x 47 cm
London, National Gallery
1654

*Self-Portrait with Palette
and Brushes*
Oil on canvas,
114.3 x 94 cm
London, Kenwood House
c. 1665

Holland

Andromeda
Oil on panel, 34.1 x 25 cm
The Hague, Mauritshuis
c. 1629

*The Anatomy Lesson
of Dr. Tulp*
Oil on canvas,
169.5 x 216.5 cm
The Hague, Mauritshuis
1632

Music Concert in Costume
Oil on panel,
63.4 x 47.6 cm
Amsterdam, Rijksmuseum
1626

*Self-Portrait with Unkempt
Hair*
Oil on panel,
22.6 x 18.7 cm
Amsterdam, Rijksmuseum
1628

*Jeremiah Lamenting the
Destruction of Jerusalem*
Oil on panel,
58.3 x 46.6 cm
Amsterdam, Rijksmuseum
1630

Girl with Dead Peacocks
Oil on canvas,
144 x 134.8 cm
Amsterdam, Rijksmuseum
1636

The Night Watch
Oil on canvas,
363 x 437 cm
Amsterdam, Rijksmuseum
1642

Portrait of Jan Six
Oil on canvas,
112 x 102 cm
Amsterdam, Six Stichting
1654

*The Anatomy Lesson of Dr.
Deyman*
Oil on canvas,
100 x 134 cm
Amsterdam, Rijksmuseum
1656

*Titus Dressed as Saint
Francis*
Oil on canvas,
79.5 x 67.5 cm
Amsterdam, Rijksmuseum
1660

Holland	Peter's Denial of Christ Oil on canvas, 154 x 169 cm Amsterdam, Rijksmuseum 1660	The Syndics of the Drapers' Guild Oil on canvas, 191.5 x 279 cm Amsterdam, Rijksmuseum 1662
	Isaac and Rebecca (The Jewish Bride) Oil on canvas, 121.5 x 166.5 cm Amsterdam, Rijksmuseum c. 1666	Accord in the Nation Oil on panel, 74.6 x 100 cm Rotterdam, Museum Boijmans Van Beuningen c. 1642
Portugal	Alexander the Great (or Athena) Oil on canvas, 118 x 91 cm Lisbon, Museu Calouste Gulbenkian c. 1655	
Russia	Saskia Dressed as Flora Oil on canvas, 124.7 x 100.4 cm St. Petersburg, The State Hermitage Museum 1634	The Sacrifice of Isaac Oil on canvas, 193 x 132.5 cm St. Petersburg, The State Hermitage Museum 1635
	Danaë Oil on canvas, 185 x 203 cm St. Petersburg, The State Hermitage Museum 1636	Holy Family with Angels Oil on canvas, 117 x 91 cm St. Petersburg, The State Hermitage Museum 1645

Russia

The Return of the Prodigal Son
Oil on canvas, 262 x 206 cm
St. Petersburg, The State
Hermitage Museum
c. 1666

Spain

Artemisia Receives the Ashes of Mausolus (Sophonisba Receives the Poison Cup)
Oil on canvas, 142 x 153 cm
Madrid, Museo Nacional
del Prado
1634

USA

The Painter in His Studio
Oil on panel,
25.1 x 31.9 cm
Boston, Museum of Fine
Arts
c. 1629

Portrait of Nicolaes Ruts
Oil on panel,
116.8 x 87.3 cm
New York, The Frick
Collection
1631

The Noble Slav
Oil on canvas,
152.5 x 124 cm
New York, The Metropolitan
Museum of Art
1632

Aristotle with a Bust of Homer
Oil on canvas,
143.5 x 136.5 cm
New York, The Metropolitan
Museum of Art
1653

Henrickje Dressed as Flora
Oil on canvas,
100 x 91.8 cm
New York, The Metropolitan
Museum of Art
c. 1654

The Polish Rider
Oil on canvas,
116.8 x 134.9 cm
New York, The Frick
Collection
c. 1655

USA

Self-Portrait with Staff
Oil on canvas,
133.7 x 103.8 cm
New York, The Frick
Collection
1658

Suicide of Lucretia
Oil on canvas,
120 x 101 cm
Washington, National
Gallery of Art
1664

Sweden

*The Conspiracy of Julius
Civilis (The Batavian Oath)*
Oil on canvas, 196 x 309 cm
Stoccolm, National
Museum of Fine Arts
1661–1662

Writings

An excerpt from C. A. Du Fresnoy's The Art of Painting, *translated from the French by John Dryden.*

Rembrandt van Ryn, born near *Leyden, Anno* 1606, was a *Disciple* of *Lasman* of *Amsterdam.*

He had an excellent Disposition for Painting. His Vein was fruitful, and his Thoughts fine and lively. But having suck'd in, with his Milk, the bad Taste of his Country, and aiming at nothing beyond a faithful Imitation of the living (heavy) *Nature*, which he had always before his Eyes, he form'd a *Manner* entirely new, and peculiar to himself. He prepar'd his *Ground* with a Lay of such friendly Colours as united, and came nearest to the *Life*. Upon this he touch'd in his Virgin Tints (each in its proper Place) rough, and as little disturb'd by the Pencil, as possible: And with great Masses of Lights and Shadows rounding off his Figures, gave them a Force and a Freshness, that was very surprising. And indeed, to do Justice to the predominant Part of his *Character*, the *Union* and *Harmony* in all his *Compositions* is such, as is rarely to be found in other *Masters*. He drew an abundance of *Portraits*, with wonderful Strength, Sweetness, and Resemblance: and even in his *Etching* (which was dark, and as particular as his *Style* in *Painting*) every individual Stroke did its Part, and express'd the very Flesh, as well as the Spirit of the Persons he represented. Agreeable with all the rest, was the Singularity of his Behaviour. He was a man of Sense and Substance; but a *Humourist* of the first Order. He affected an old-fashion'd, slovenly Dress, and delighting in the Conversation of mean and pitiful People, reduc'd his Fortunes at last to a Level with the poorest of his Companions. He died *Anno* 1668, *Æt.* 62; for nothing more to be admir'd, than for his having heap'd up a noble Treasure of *Italian Prints* and *Drawings*, and making no better use of them.

An excerpt from C. J. Nieuwenhuys's A Review of the Lives and Works of Some of the Most Eminent Painters.

Houbraken was the first Dutch writer who published some anecdotes relative to the life of Rembrandt; but

he appears to have been in possession of little information respecting him. Succeeding authors have only repeated what he said, and if they have multiplied the anecdotes, they have only rendered the truth still more confused, because they have not added any thing on proper authority. For this reason I shall adhere to such facts as are proved in the extracts, which persevering researches upon this subject have enabled me to obtain.

With regard to the date of Rembrandt's birth, we have no other authority than that of Houbraken, who mentions that the year 1606, which was particularly fertile in excellent artists, gave birth also to Rembrandt van Ryn, on the 15th of December, in the neighbourhood of Leyden. He was the only child of Herman[1] Gerritzen van Ryn and Neeltje Willems van Zuitbroek, who possessed the corn-mill which was situated between Leyerdorp and Koukerk: from this humble habitation rose one of the greatest men which the genius of art ever nursed. His parents, observing his early inclination for study, did not neglect the cultivation of his mind, and for that purpose they resolved to send him to the Latin school at Leyden, in order to bring him up to a learned profession: but his predominating taste for painting caused them to alter their views, and place him with Jacop Izakzen van Zwanenborg, who instructed him in the rudiments of his art during the three years that he remained with him. From this period, Houbraken is in doubt who was his principal master, for he informs us that he passed six months with P. Lastman at Amsterdam, afterwards a short time with Jak. Pinas, and then refers to Simon van Leewen's short description of Leyden, where the latter says that Joris van Schoten and Jan Lievensz were those who taught Rembrandt the art of painting. But there is every reason to believe that his principal master was Peter Lastman, because Rembrandt's first works resemble those of that artist. His remarkable progress, however, attracted the attention of many amateurs; for we are assured by Houbraken that, about that period, he sold one of his pictures to a gentleman at the Hague for 100 guldens, which was a tolerably large price at that time. He was so satisfied with the remuneration, that he resolved not to return home on foot—

the mode of travelling by which he had reached the Hague, but departed in the diligence, elated with joy at being able to announce the good news to his parents. Fearing to lose his money, he would not descend from the vehicle when the passengers stopped on the road to take refreshment, but remained alone in the coach, when the horses, being left free, took fright and ran away to Leyden; and on his alighting at the inn where the animals were accustomed to stop daily, every one was astonished that the young Rembrandt, travelling without a coachman, had arrived in safety. Declining to give any explanation of what had happened, he left the coach, and hastened to his father's habitation, which was situated at a short distance from the city.

This was the *début* of this extraordinary man, who now began to know his own worth; and whose genius, excited by a laudable ambition, enabled him very soon to perform wonders. Amsterdam was then the centre where talent was received with applause; and Rembrandt, encouraged by several patrons, decided upon establishing himself there, about the year 1630, taking up his residence on the Bloemgraft. From that time he began to distinguish himself in the great world, for the picture he completed in 1632, and which was placed in the Anatomical Theatre of the College of Surgeons, proved what he was able to produce[2]. This chef-d'œuvre represents Professor Nicolas Tulp giving an anatomical lecture on a body, which is stretched upon a table before which he is sitting; the audience is composed of seven other persons, Jacob Block, Hartman Hartmansz, Adriaan Slalbraan, Jacob de Wit, Matthys Kalkoen, Jacob Koolveld, and Frans van Loenen, who are so admirably represented that it appears as if each countenance was penetrated with the explanations he is giving. The pen cannot describe the wonder of the art; here the work of man triumphs in rivalling nature; for the expression of life and the representation of death are so strongly depicted that the impression this picture makes, strikes the spectator at first sight with a feeling of aversion; yet, contemplating the *ensemble*, one discovers not only the great painter, but also that knowledge of human feelings which speaks so forcibly to the heart,

and which corresponds perfectly with what he often said to his pupils, "that he had made it a strict rule never to paint any thing without following nature."…

The accounts now produced have never been published, and are particularly interesting, as they develop many peculiar circumstances in Rembrandt's history; who, beginning to be prosperous, determined to become proprietor of a house situated in the *Bree-Straat*, near the *St. Antonis-Sluys*. To assist him in effecting this purpose the burgomaster Cornelis Witsen advanced him 4,180 guldens, on a mortgage on the property; not being able to meet his engagement, when this bond fell due, all his goods were seized, and on the 25th and 26th July, 1656, the commissioner of the Court of Insolvency in Amsterdam made the following inventory, which is translated from the original manuscript:—

REMBRANDT VAN RYN.

Extract from the Register of Inventories marked R., deposited at the Administration Office of Insolvent Estates at Amsterdam, Anno 1656.

Here Follow the Books of Art.

A book, bound in black leather, with Rembrandt's best sketches.
A band-box, full of engravings, by Hupe Marten, Holbein, Hans Broesmer, and Israël Mentz.
Another book, with all Rembrandt's etchings.
A book, full of drawings, done by Rembrandt, representing academical studies of men and women.
A ditto, full with drawings of all the Roman edifices and views, by the most celebrated masters.
A Chinese casket, full of cast ornaments.
An empty album.
A ditto, as above.
A ditto, full of landscapes, drawn after nature, by Rembrandt.
A ditto, with proof engravings of Rubens and

Jaques Jordans.
A ditto, full of drawings, by Mierevelt, Titian, and others.
A Chinese basket.
A ditto, full of architectural prints.
A ditto, full of drawings, by Rembrandt, representing animals taken from nature.
A ditto, full of engravings, by Frans Floris, Buytenoech, Goltzius, and Abraham Bloemart.
A parcel of drawings from the antique, by Rembrandt.
5 books in quarto, full of drawings, by Rembrandt.
A ditto, full of architectural engravings.
The Medea, by Jan Six, a tragedy.
Engravings of Jerusalem, by Jacob Callot.
A parchment book, full of landscapes, drawn after nature, by Rembrandt.
A ditto, full of sketches, by Rembrandt.
A ditto, ut supra.
A wooden box, with slides.
A small book, full of views, drawn by Rembrandt.
A ditto, with fine writings.
A ditto, full of drawings from statues, by Rembrandt.
A ditto, ut supra.
A ditto, full of sketches, by Peter Lastman, drawn with the pen.
A ditto, by Lastman, drawn with red chalk. A ditto, full of sketches, by Rembrandt, drawn with the pen.
A ditto, ut supra.
A ditto, as above.
Another small book, by Rembrandt.
A ditto, with large drawings, taken from nature in Tirol, by Roeland Savery.
A ditto, full of drawings, by several renowned masters.
A ditto, in quarto, full of sketches, by Rembrandt.
Albert Durer's [Albrecht Dürer's] book of proportions, with wood-cuts.
Another unbound book, with engravings, being the work of Jan Lievensz and Ferdinandus Bol.

Some parcels, with writing, by Rembrandt and others.

A parcel of paper of a large size.

A box, with engravings by Van Vliet, after paintings by Rembrandt.

A screen, covered with cloth.

An iron gorget.

A drawer, in which is a bird of Paradise and six fans.

15 books of different sizes.

A German book, with martial figures.

A ditto, with wood-cuts.

A German Flavius Josephus, ornamented with engravings, by Tobias.

An old Bible.

A small marble inkstand.

The plaster cast of Prince Maurice.

In the large Painting Room.

20 pieces of halberds, double-edged swords, and Indian fans.

An Indian man's and woman's dress.

A giant's casque.

5 cuirasses.

A wooden trumpet.

Two Moors represented in one picture, by Rembrandt.

A child, by Michel Angelo Buonaroti.

[1] According to Houbraken; but it appears by the extract… from an original document deposited at the Administration Office of Insolvent Estates at Amsterdam, dated 1658, that his father's name is spelt Harmens.

[2] The directors of the *"Snei-Kamer,"* or Anatomical Theatre, resolved to sell this picture by auction, for the purpose of augmenting the funds for supporting the widows of members, and in consequence the sale was announced for Monday, 4th August, 1828. Since the year 1632 until this period it had always remained in that establishment, as a gift from Professor N. Tulp, who presented it as a remembrance of himself and his colleagues. The writer had no sooner learned that the piece in question was to be sold, than he went to Amsterdam, with the intention of purchasing it; but upon arriving was informed that His Majesty the King of the Netherlands had opposed the sale, and given orders to the Minister for the Home Department to obtain it for the sum of 32,000 guldens, and caused it to be places at the Museum at the Hague, where it remains. The picture is on canvas; height 64 1/2 inches, width 83 1/2 inches.

An excerpt from the Fine Arts Quarterly.

In Rembrandt's house in the Breestraat, besides upwards of 150 pictures in oil, most of them by himself and his pupils, but some of them by Van Eyck, Raphael, Giorgione, and Michel Angelo; besides casts from the life of whole and parts of figures and animals, statues, antique busts, arms and armour, wind and stringed instruments, zoological, mineralogical, and botanical specimens, costumes, and every conceivable accessory to artistic suggestion and production—were found nearly one hundred volumes of the prints of all the great painter-engravers who had flourished in Europe from the discovery of the art to his own time—Schoen, the Meckens, Lucas Cranach, Lucas of Leyden, Dürer, Vandyke, Rubens, Hollar, Holbein, Jordaens, Andrea Mantegna, Bonasone, Titian, Guido, Tempesta, the Caracci, &c; the most precious works (we quote the catalogue) of Marc Antonio, after the designs of Raphael; together with a supplementary collection of the prints of contemporary artists, who, as they are not mentioned by name, were probably the etchers. In a word, not only a complete illustration of the engraver's art as it had been practiced for 200 years, but an almost equally complete representation of Art itself, as it had existed since the revival. The Gothicism of the Germans, the academicism of the Italians, and the realism of the Flemings, had here each a fair and, as exemplified in their engraving, a more ample demonstration that they had ever received before—the graceful contours of Marc Antonio conveying a refined ideal of that kind of beauty which depends upon form—the complex but more dexterous curves and inflexions of Albert [Albrecht] Dürer, not devoid of a certain semi-barbarous expression—the noble simplicity of Andrea Mantegna—the strength of

Rubens—the weakness of Guido—the truth of Holbein—the courtly artifice of Vandyke. Rembrandt availed himself of this vast collection as a man who lived only for his art would. It was an open book to him to which we find him making constant reference; at one time adding to its stores by bidding chivalrous prices for single prints of masters with whom he might be supposed to have little sympathy, but in whom, doubtless, he saw a quality which he thought cheaply acquired at any price; at another making elaborate studies of subjects which interested him or which served his immediate purpose. To this collection and to his numerous copies of the Oriental drawings which it contained—prompted, of course, by the innate sentiment which led him to use them for such a purpose—we probably owe it that of all the men who have undertaken to illustrate the Bible, he is the only one that has been able to give faithful expression to its simple reality and to make us personal sharers in the homely and impressive incidents with which it abounds. Who, for instance, that has seen that commonest of his etchings the *Return of the Prodigal* [Son], or that still more affecting one of *Tobit*—the stricken old man vainly feeling for the door which is within a foot of him— or the little subject full of grief of the disciples carrying our Lord to the burial; or the so-called *Death of the Virgin*—the body slipping towards the foot of the bed, as dying bodies do—without being sensible of this faculty, and of the deep natural tenderness of character by the promptings of which alone their author could have produced them? To the influence of Titian, again, whose drawings Rembrandt possessed, we owe the splendid backgrounds of some and whole subjects of others of his etchings; while, in a minute copy of a morality of Andrea Mantegna's, we have a singular proof that the quaint but impressive work of the earliest and most simple of his predecessors was not without its influence upon him. We have been thus particular in directing attention to the copious use made by Rembrandt of his collection, because we wish to show that it was not without due warrant and consideration that he broke through the prescriptions of two centuries, and because it presents the great student to us in a noble aspect and in a character as far removed as possible from that of the charlatan and the cheat. Then, again, what man more competent or more likely than he— surrounded by all that was accounted great in art— to perceive and to weigh, to select and to turn to account, whatever he thought worthy of his adoption, or—if he had found a better—to amend the practice he had begun in his father's mill?

Excerpts from John Lafarge's Great Masters.

"When I desire to rest my mind, I do not seek honours, but liberty." —Words attributed to Rembrandt.

Drawing for its own sake, form for its own sake, colour for its own sake do not exist for Rembrandt. They are all so fused together that in such a picture as that just mentioned [*Supper at Emmaus*] the execution is so simple and yet so involved that no one would dare to think of the possibility of copying it.

And yet for many there has been a great desire to imitate him in some obvious ways, and his pupils were many, who had his help and occasionally gilded into the manner of the master. We do not know what he taught. It must have been of extraordinary importance, for it involves all that there is in the art of painting. He might have shown them the secrets of his earlier work, which is more connected with the work of the Dutchmen around them. He was careful, apparently, of their individuality, and taught them separately; though also they must have helped him, as was the fashion of all those days. They did so, even in his etchings, the method of which is more personal can be that of painting, because there are fewer steps between the beginning and the end; while painting, which is made up of surfaces covered one by the other, may allow indefinite amount of work, well directed by one man, to be covered completely by the last veilings and touches, which are really the painting that we see. Why did he change as he went along? Why was he not suited with his

manner when he painted "The Lesson in Anatomy," where Dr. Tulp addresses the Regents or Inspectors of the Hospital? Surely this masterpiece of his early days, for he was only twenty-six years old, is a work sufficiently perfect and complete. We recognise that his great characteristic is the anxiety to express still more in the same direction. The painter of *appearances* had early attained a power of formulation sufficient for a great place in art. Apparently the student and worker kept on observing the infinite modifications of nature. These studies were accompanied by the experiences of life. To express that succession of experience and feeling, which was himself, some more intimate, more delicate, more powerful means were necessary than what might do to paint a handsome face, or brilliant eyes, or the velvets and satins which make for instance the portraits of Burgomaster Van Beeresteyn and his wife so delicious to the eye, so sincere and honest in the rendering of the things seen.

As time went on he risked the changing of his manner, endangering sometimes the beauty of certain details. He had for his use only his past habits, his own and those of his school, for he differs only from them by being what we call Rembrandt. He had about him common models, or at the best people whose forms were not heroic. The habits about him were vulgar where they were not plain and orderly. The costumes were sober, or if rich were eccentric…. What is distinct and beautiful is apparently his alone. For the building of the great structure of the painter, the planes and directions of planes, the intersection of lines, what is called the interior structure, his abundant etchings and drawings must have made him master. Even in the paintings occasionally, in the obscurity of corners, he resorts to those abbreviations which his etchings and drawings show, a manner of starting only a few points which the mind fills in. I remember in a painting of "The Christ at Emmaus," which is at Copenhagen, and which I copied in my youth, trying to follow, touch by touch, a great dog lost in the shade, only appearing occasionally to the eye as if a little more light might make him more distinct; and

this beast was made of only five or six touches of definite space and colour, being in paint what the few scratchings of his etchings suggest to us in black and white. Perhaps, after all, the etchings and drawings tell us more about himself, about his completeness of study, his intensity of perception, and the extraordinary sympathy and feeling which separate him from all other artists. There he could—for he was Rembrandt—throw away the greater part of his armour of art. Perhaps in the drawings in which he worked entirely for himself we see still more intimately the mind of the master…. With the great public and for us of the profession, the famous picture, painted seven years before his death, known as "The Syndics of the Drapers' Guild," represents perhaps the result of all his work as a mere painter. In it he is young again notwithstanding his approaching age; but all that he has learned, his thoughts during life, have helped him make it. All the more do we feel this, because this one picture brings in nothing but portraits, all separate and individual, but so connected that one sees them at a blow. There is no apparent arrangement as in "The Lesson in Anatomy." They are doing nothing in particular more than what would take them around a table to listen to the reading of accounts, and yet the appearance of importance of a number of men chosen for a purpose of decision has never before or afterward been so well expressed. They almost speak, but do not open their lips. They are not posed. They are there. The slightest change and they would be sitting for their portraits, but they are not. They have, as it were, been surprised by somebody's opening the door, by some paper brought to them, and one sees what they have been doing before, and what they will return to. The painting as mere painting is as wonderful as that of the most beautiful surfaces ever covered by the brush. Rembrandt has joined here to deep appreciation of character that observation of life as it looks, which was the aim of his art; that is of the artist in the man. The man himself, as I have said, apart from a few paintings, is better seen through the etchings or the drawings. They have all the superiority that belongs to the dependence on few things and a careful selection in

those. Not that they are separated from his pictures in any way, nor can we disentangle them. But we see in them his predilections and the external things on which he bases his dreams. For after all, it is as the great dreamer that Rembrandt stands almost alone, unless we chose to think of him with such other dreamers as Michelangelo or Shakespeare. He remains the great exponent of the pity and tenderness of the Bible story, of its being of all times, and a synopsis of all human life; and he remains, as well, the master of many realities, the poet of the mystery of light, and the painter of the individual human soul.

*A*n excerpt from Malcolm Bell's The Drawings of Rembrandt van Rhijn.

That he did not strive for, let alone attain, the elegance and grace of a Raphael is a circumstance that needs neither excuse nor explanation. It was not the spirit of his age or race to mince matters, and things were done and spoken of with an openness which it is thought necessary to cry out upon in this mealy-mouthed, though scarcely more moral time. Rembrandt had probably no conception of, certainly no sympathy with, the Abstract Nude. He never, it may be admitted frankly, lost sight of sex, in fact he would seem to have deliberately insisted on it, since the theme he most often selected was that story of Susannah and the Elders which modern propriety has banished to the Apocrypha, and, whatever semi-transparent veil of meaningless mystery we may nowadays pretend to draw over obvious and vital facts, he spoke out as a man, with a man's strength, and saw no need for shame. Man had not begun to regard innocence and ignorance as synonymous terms, nor rewritten the old saying in its present form, "To the aggressively pure most things are impure."

From another of the apocryphal books Rembrandt drew even more frequent inspiration. The story of Tobit evidently appealed to him with a force that is difficult to account for. In paintings, etchings, and still more frequently in drawings, he treated almost every phase of the narrative, often repeating the same incident over and over again. This habit of constantly returning to the same subject, sometimes merely revisualising the scene and reconstructing it from an altogether fresh point of view, was one of his most marked characteristics. *Joseph Visiting the Prisoners*, to which presumably the possibilities of the gloom of the dungeon and the concentration of the illumination attracted him, is found in two wholly different versions in the national collection. *Esau Selling his Birthright* and *Abraham Dismissing Hagar and Ishmael* also occur in two renderings. A curious and interesting example of his methods in revising and correcting a design is revealed by an examination of the drawing… representing Christ taken down from the cross, which was probably made in 1642, since the picture subsequently painted from it, which is now in the National Gallery, bears that date. Only portions of the first conception satisfied the exacting painter, and the rest was obliterated by means of pieces of paper cut roughly to the outlines of the parts retained and gummed on to the original drawing. These were worked over with black and red chalk and bistre wash, but, the result still falling short of the artist's ideal, more fragments were added, until the result as we have it now is a perfect mosaic, consisting of some sixteen fragments of paper, while, in addition to the chalk and wash, oil-colour was freely applied when the surface was unable to receive further impressions from any less solid material. A no less instructive specimen is the red chalk drawing, dated 1630, which discloses the odd fact that Rembrandt, on this occasion at least, after planning an arrangement of light and shadow-masses for one subject, in this case *The Raising of Lazarus*, re-adapted it by the later addition of further figures to another and entirely different one, *The Entombment of Christ*; and it further shows us, if that were needed, to how large an extent Rembrandt's imagination worked primarily in terms of light and shadow, how in his mind's eye he first saw the illumination of the subject, and how the disposition of the figures was merely a secondary matter. A wonderful instance, on the other hand, of the definiteness with which at times he perceived what

he would have in its completeness and reproduced it with unhesitating dash and vigour may be seen in the sketch for *The Good Samaritan Arriving at the Inn*. In this the painter's brush has never for an instant faltered; his sense of relation, his judgment of the appropriate distribution of light and darkness, have never failed him, and the former has been left, the latter added, with a confident assurance that even in Rembrandt is amazing. The effect is at the same time so satisfactory for its decorative qualities, and so complete as an exposition of the incident, that one can but wonder that Rembrandt, as far as we know, never made further use of it, for the picture of 1648, now in the Louvre, bears but a distant resemblance to it. The fact would seem to be that Rembrandt's creative energy was so prodigious, his imagination so prolific, and his passion for reducing his teeming fancies to concrete form so overwhelming, that he could not but lay up far more material than the longest life could deal with. Though he never, as the drawings show, wasted time in labouring unnecessary detail, though his manner of statement was a model of concise thoroughness, and though he lived only for the work he loved, and pursued it with an untiring persistence which has rarely been excelled, his hand, swift and skillful as it became, was never able to keep pace with his mind.

The etchings and the paintings show us what he did achieve. The drawings not only give us glimpses of the minuter and more recondite methods of his achievement, but reveal, as it were by lightning flashes in the darkness of midnight, faint adumbrations of what, had time and fate allowed, he might have achieved further. The magnificent sketch of *Abraham Sacrificing Isaac* has attained its full realisation, and the oil picture now hangs in the Hermitage at St. Petersburg; but the more carefully finished drawing representing an old man of venerable and dignified appearance, accompanied by two angelic figures, approaching a man who prostrates himself before them on the threshold of a stately mansion beneath the shadow of a wide-spreading tree, remains a delightful but uncompleted vision.

An excerpt from Georg Simmel's Rembrandt: an Essay in the Philosophy of Art, *translated by Alan Scott and Helmut Staubmann.*

CONTINUITY OF LIFE AND THE MOVEMENT OF EXPRESSION

Life… is a unity, but one that at any moment expresses itself as a whole in distinct forms. This cannot be deduced further because life, which we attempt to formulate here in some way, is a basic fact that cannot be constructed. Each moment of life is the whole life whose steady stream—which is exactly its unique form—has its reality only at the crest of the wave in which it respectively rises, Each present moment is determined by the entire prior course of life, is the culmination of all preceding moments; and already, for this reason, every moment of life is the form in which the whole life of the subject is real.

If one is searching for a theoretical expression of Rembrandt's solution to his problems of movement (whether great or small), it is to be found within the frame of this conception of life. Whereas in classical and, in the narrower sense, stylizing art, the depiction of a movement is achieved via a sort of abstraction in that the viewing of a certain moment is torn out of its prior and concurrent stream of life and crystallizes into a self-sufficient form, with Rembrandt the depicted moment appears to contain the whole living impulse directed toward it; it tells the story of this life course. It is not a part of a psycho-physical movement fixed in time where the totality of this movement—of this internally unfolding event—would exist beyond the artificially shaped being-in-itself. Rather, it makes evident how a represented moment of movement really is the whole movement or, better, is *movement* itself, and not some petrified something or other. It is the inversion of the "fruitful moment." While the latter leads the movement for the imagination from its current state into the future, Rembrandt collects its past into this here and now, not so much a fruitful moment but a moment of harvesting. Just as it is the nature of life to be at every moment there as a *totality*, since

its totality is not a mechanical summation of singular moments but a continuous and continuously form-changing flowing, so it is the nature of Rembrandt's movement of expression to let us feel the whole sequence of its moments in a single movement—overcoming its partition into separated sequential moments. From the way in which most painters represent these movements, it would seem as if the artist had seen, either in imagination or from a model, how a certain movement looks, and had arranged, realistically or not, the picture according to this outcome—perfected in terms of the phenomenon that had reached the surface.

With Rembrandt, however, the impulse of movement—as it emerges from its kernel laden with or guided by its inner meaning—seems to form the basis. And out of this germ—this concentrated potentiality of the whole and of its meaning—the drawing develops part by part, just as the movement unfolds in reality. For him, the starting point or the foundation of the depiction is not in the image of a moment as viewed from the outside, as it were, in which the motion has reached its portrayable zenith—a self-contained cross-section of its temporal course. Rather, it contains from the outset the dynamic of the whole act concentrated into a unity. The entire expressive meaning of the movement, therefore, lies already in the very first stroke. This stroke is already filled with the viewing or the feeling that is contained, as one and the same, within the inner life and the external movement. In this way it becomes comprehensible that the figures in his sketches and roughly sketched line etchings (even more noticeably than in the paintings) in which there is only a minimum of lines—one might almost say that nothing appears on the paper—still convey an absolutely unambiguous attitude and movement, and hence the inner condition and intention in its full depth and with full persuasive force. Where the movement is regarded in the definitive state of its representation—in the extensiveness of its phenomenal moment—it requires, in principle, a completeness of its appearance in order to achieve its full expression. But here it appears as if a person wants to express the deepest emotion pervading him completely. He does not have to utter the entire sentence that logically displays the content of that which moves him, since the tone of voice of the first words already reveals all.

Naturally, that does not mean that there is an absolute difference between Rembrandt and all other artists. We are dealing with differences of principle. As principles, they are diametrically opposed, but empirical phenomena represent a greater or lesser degree of participation in both principles. This is all the more evident as movements of expression in the younger Rembrandt commence from the mere exterior perspective. This can be seen, for example (referring now only to the paintings), in the way the bodies move in *The Rape of Europa* of 1632, or the slightly later *Mene Tekel*, or *The Incredulity of Saint Thomas*. Here we find only the fixed appearance of a moment of movement. Then, around the time of the *St John the Baptist Preaching* (in Berlin), the movement animated from within itself, prepared in the deepest psychic stratum, begins to appear as that which, with variations right up to the 1640s and even the 1650s, finally bestows unique character on his paintings.

His artistic vision contains not simply the visibility of the gesture in the moment of its representation. His vision's meaning and intensity originate, so to speak, not on the first level of viewing, but already direct and fill the first stroke that, therefore, completely reveals the totality of the inner-outer process (in its characteristic artistic inseparability). Just as it appeared as the deeper formula of life that its totality does not exist outside of its individual moments, but, on the contrary, exists fully in each of them because it consists exclusively in the movement through all these opposites, so the moving form in Rembrandt reveals that there is no *part* in the self-realization and self-presentation, as it were, of an inner fate; that, moreover form a certain perspective of representation, each isolated part is the totality of this inner and expressive fate. That he is able to represent each small part of the moving figure as its totality is both the immediate and symbolic expression of the fact that each of the continuously connected moments is the whole life as it becomes personalized in the form of this particular figure.

However, this individualization—as I sought to interpret it here as a life that is developed and grasped from within—bestows a different sense of another type of "necessity" on the "form" than does classical art. Rembrandt's predilection for ragged appearances, for the proletarians whose clothes, due to the haphazardness of their poor lot, appear in formally quite senseless tatters, seems almost to be a conscious opposition to the latter's principle. Compare this to the few equivalent figures in Italian painting whose threadbare rags are accommodated within a principally formal concept. In classical art, form means that the elements of appearance determine each other via a mutually effective logic; that the shaping [*Geformtheit*] of one immediately demands the shaping of the other. With Rembrandt, form means that a life flowing from a source has brought forth precisely this form as its result, or as the clearest instance of intuition of its totality as it exists in the form of becoming. It is as though Rembrandt experiences in the symbolic representation, in which the artist reconstructs his object within himself, the total life impulse of a personality as though it were gathered at one point. And he develops this through all the scenes and fates up to its given appearance so that—fully corresponding to the individual movements— this apparently individual moment stands before us as something that developed from a distant beginning and concentrated its coming into being within itself. That which we have just articulated merely as a principle, but in the nontransparent, confused reality of experience can be perceived only imperfectly and accidentally, namely, that each moment of a life is the whole life—or, to be more precise, is life as a whole—artistic expression makes manifest in its purity and clarity. If each Rembrandt face finds the determination of its actual form in its whole history, so its individual contents cannot be read out of it. Rather, this alone becomes visually convincing: from the beginning, and in the potentialities of this being, a course of becoming leads up to and determines this actuality. It has come to be that which stands there [in the painting] through life's inner dynamic and logic.

Precisely this is foreign to Rembrandt: that the actual appearance purely as such—independent of that which in a historical-biographical sense exists before it, in a transcendental and mental sense behind it, in a psychological sense inside it—could possess a formal law that would belong to its self-sufficient appearance. Nothing like *contrapposto* [counterpoise] is, except by accident, to be found in this case. Everything is determined from the inside. And the wonder is that this produces a *pictorially* valuable appearance, just as it is a specific miracle of art that the greatest among the works of art that strive in the reverse direction—from the pure appearance toward its purely artistic forming—thereby simultaneously attain the expression of all inner, rather than immediate visual, values. But it still explains why some mere painters could and would not understand Rembrandt's means and effect.

Here again the contrast between the Renaissance portrait and those of Rembrandt is to be formulated on the basis of the ultimate categories of the conception of the world. The two concepts between the interpretation and evaluation of which being has to decide at each point are: life and form. According to its principles, life is quite heterogeneous, distinct from the principle of form. Even if one says that life consists in continuous change, and in the destruction and re-creation of forms, so this, too, is easily misunderstood. It appears to presuppose that somehow—ideal or real—fixed forms exist, each of which is accorded only an extremely short duration in that life creates or reveals them. However, that which we really call life would then consist only in movement that shifts between one form and the next, and would only exist during the interval that transforms one [form] into the other because forms, as somehow stable entities, cannot place themselves within life that is absolutely continuous movement…. The current itself develops in the continuing effects of its force without, as it were, concerning itself with the image that it may provide for some external perceiving view.

185

Perhaps the responses that some of Rembrandt's figures arouse (particularly after having been impressed for a long time by classical Romanesque art) is connected with this constellation, as if what we call beauty would actually only be an exterior addition to the nature of the human being clinging to its surface stratum, not developing out of the innermost source of the nature in the course of life, as though it were something like a frame or a schema into which a human being is put. Certainly, there are other justified conceptions of beauty that connect it more deeply with life. Yet, it is still a peculiar fact that all of the great values with which our mind gives meaning to existence, only beauty realizes itself also in the nonliving. Only that which has inner life can create moral values. There can only be truth for the mind. Only the living can create power in a deeper, value-like sense (in contrast to the mere sums of energy of mechanic movement).

Beauty, however, can adhere to the stone, to the cascade and its rainbow, to the drift and the coloring of clouds, to the inorganic as to the organic. Where the specific quality of life seeks its immediate expression, as with Rembrandt, there beauty is something too broad, something that reaches too far beyond life as such, to bind the object to it. And where beauty is grasped most profoundly, there it is the symbol of the ultimate values of existence, of a moral, vital, generic kind —but still a symbol, even where it may point in a mediated way to the deepest foundation of things. Rembrandt's artistic nature, however, is characterized precisely by the renunciation of all symbolism—by an unmediated grasping of life. In this immediacy, with which Rembrandt's figures allow their life to be felt, rests that which one could call his realism and that which makes him indifferent toward the specificity of beauty.

For all art that is limited in its tendency toward the latter is either shallow, or, where it has depth, it is symbolic—that is, it departs from that immediacy in order to supply us with values and meanings in the form of intuition or allegory, of idea or mood. So it may be logical in this way that Rembrandt's figures, whose immense significance and impression develops out of the root point of life left exclusively to its own driving forces, have not been led by all that toward "beauty."

An excerpt from J. N. Laurvik's preface to the Catalogue of the Loan Exhibition of Drawings & Etchings by Rembrandt from the J. Pierpont Morgan Collection.

His line is never line for its own sake, nor did he ever present anything is outline, detached and out of relation to its environment. We now know that the idea of relativity is one of the highest and least commonly understood of all philosophical concepts, the true key to any real comprehension of time and space and all that moves and has its being therein. Rembrandt was the first practitioner of the plastic arts to realize the full significance of this law of relativity, and his marvelous chiaroscuro (that delicately organized juxtaposition of opposites with its subtle interplay of light and darkness wherein one plane impinges on another, merging into its successor, thereby stimulating the very spirit as well as appearance of reality), this magical chiaroscuro, is his expression of this profound insight.

By means of his subtle and poetic application of this generic principle he created at once the physical as well as the psychological *milieu* appropriate to his subject. And this is his great triumph, the secret of that intangible element in his work which endows it with the mysterious vitality of life itself, giving to his men and women a personality more clearly defined and consequent than that of most living persons, because they are, so to speak, all of a piece, seen in true relation to their environment. He was the first of realists, perhaps the only absolute realist so far produced in graphic art, in the sense that he above all others apprehended and expressed that inner reality which gives force and validity to the outward seeming, affirmed in a letter to one of his friends, in which he said his constant effort was to put into his works "as much of life and reality as possible."

*A*n excerpt from Joseph Cundall's The Life and Genius of Rembrandt.

Of the two pictures in Rembrandt's broad manner exhibited here at Amsterdam in the National Museum, the one dated 1642 has a special renown. This composition is celebrated all over the world by the name of *The Night-Watch* (de Nacht-Wacht). We see in it a company of citizens, who with their captain, the Chevalier Frans Banning Kok, of Pommerland and Ilpendam, and their Lieutenant, Willem van Ruytenburd, of Vlaardingen, are setting forth on some shooting expedition. One of the armed bourgeois is loading his arquebus, another wears a crown of oak-leaves on his helmet, and, in the first sketch, a boy runs up to him with a powder-flask. Amongst the moving multitude we see a young girl, in festal array, who carries a white cock attached to her belt, probably designed for the victor. This incomparable work has already gained universal admiration on account of the excellence of its arrangement and the extraordinary force of its execution, by means of which the painter, apparently by slight effort, has produced the most striking effect. A competent judge, Nieuwenhuys, has most justly said, "Rembrandt's Night-Watch, without exaggeration, is, as a production of art, one of the marvels of the world, and the Museum of Amsterdam may well be proud of it."

Although less rich in composition, the second picture preserved at the Amsterdam Museum does not fall short of the first in its power and truth. This work, painted in the year 1661, represents a meeting of Syndics (*Staalmeesters*). Four of these gentlemen are seated round a table covered with a red cloth, on which lies an open book: the fifth has risen; behind them stands a sixth person, probably a servant, with his head uncovered. They appear to be deliberating on the affairs of their administration, and are all looking up attentively, as if some one had unexpectedly appeared to them. As tot he distinctive character of this painting, it is the same as with all Rembrandt's. We feel more than we can describe. Enter a rich collection of pictures, where amongst many *chefs-d'œuvre*, there is some one production of Rembrandt's brush, and involuntarily, your look will be attracted towards it, without your being able to give any account to yourself of your impression.

Rembrandt left several celebrated pupils. Gerard Douw, Ferdinand Bol, Govert Flinck, and Gerbrand Van der Eeckhout, have obtained an undoubtedly high position as painters. But although formed in his school and penetrated by his ideas and principles, they have not entirely seized and rendered one peculiar originality of their master—an originality the cause of which must be sought, not in the secret of his manner of working, as is ordinarily asserted, but in the secret of his Genius....

I should be doing wrong to Rembrandt's genius if I passed by in silence his celebrated etchings; for he shone no less as an etcher than as a painter. The same original theory of light and colour which he followed in his painting, he applied also to his engraving. He painted, so to speak, on the copper, and gave to his works in aquafortis, as well as to his paintings, the vigour and distinctness to which they owe their brilliancy and softness of tone. He seems sometimes to have played with his point, yet nevertheless he never traced an unintentional line, or made a useless stroke. All his works bear the marks of just conception and profound reflection.

*A*n excerpt from Amy Golahny's Rembrandt's Reading.

AMOROUS MYTHS FROM OVID

A similar pattern of picture and texts, as found in the *Proserpina*, contributed to Rembrandt's sources for three other early mythological paintings: *Andromeda, The Abduction of Europa,* and *Diana and Actaeon with Callisto and Nymphs*. For these, Ovid's *Metamorphoses* was the narrative authority. Portions of the *Metamorphoses* belonged to the 1625 *Schoolordre*, and would have been read at the Latin school. For Rembrandt, as for other artists, the Dutch translation by Florianus, first published in 1552 and often reprinted, was adequate. Van Mander's abridgement in *Het Schilderboeck* presented the myths in brief and with moralized commentary; this text was

useful, but did not generally furnish the narratives with sufficient detail for the artists' representations. For Rembrandt, the Ovidian narrative was a vehicle for the nude, the passions, erotic humour, and pastoral landscape.

In these myths, Rembrandt's goal was to invent original responses to visual and textual precedents. He conflated textual moments that had been hitherto rendered as pendant images, isolated a moment from a larger text and from illustrated series, excerpted visual motifs from various contexts, or departed from visual tradition in other ways. There is no single approach that can explain the myth renditions except the search for novelty, and it is distinct in each case. Only in *The Abduction of Proserpina* was the authoritative text not translated into Dutch. S. Grohé concluded that in each of the six paintings, Rembrandt concentrated upon producing an image of a *Pathosformel* (rhetorically grounded representation of the passions). Such an underlying principle is consistent throughout his work, whether in dramatic outward or serene inward forms of expressiveness.

The smallest and earliest of these paintings is *Andromeda*. Its general composition may have been suggested by the illustrated astronomical manuscript by Aratus, a prized possession of the Leyden University library, which was published in 1621 with engravings by Jacques de Gheyn II. In the *Metamorphoses*, Ovid related how Perseus flew over Ethiopia and saw the beautiful Andromeda chained to a rock and menaced by a sea-monster; this punishment was decreed by Jupiter for her mother's boast that she herself was more beautiful than the sea-goddesses. Perseus approached, asked her name, and inquired about her circumstances. She at first was shy, then told him everything. Hardly had she finished when the sea monster menaced her anew and her parents, watching up on the shore, lamented; resolving to be of help, Perseus offered to rescue the girl if her parents would consent to his marrying her. The ensuing battle between Perseus and the sea-monster is a long, noisy, and violent struggle:

"… Finally he came flying with his sword drawn, and gave a blow to the right shoulder of the fish, upon which the monster began to leap, and became

more agitated, jumping sometimes into the air, sometimes also deep into the water, all the while he had him struggling, like a wild boar surrounded on all sides by the hounds… but seeing next to him a rock, that projected over the water, he went there to stand, and holding his left hand fast to the rock, he continued the struggle with his right hand, striking and piercing his enemy with his sword three or four times, so that at last he defeated him."

The rock was important to Perseus' victory, for it provided a natural barrier from which he achieved his final and winning assault. Within the rich pictorial tradition, Andromeda is always chained to a prominent rock. Typically, the monster flails in the sea, thereby establishing the danger to the maiden; either Perseus flies down to attack the monster, or, having vanquished the beast, Perseus tenderly approaches Andromeda. Rembrandt isolated Andromeda from her family, the monster, and Perseus. Rembrandt's Andromeda expresses tension in her inclined head, her puckered brow, and her twisting shoulders; she is listening to Perseus' attack on the sea monster, a combat that generates quite a lot of noise. She gives her attention to what is not shown to the viewer—who must supply the narrative.

The Abduction of Europa of 1632 departs from convention in the pastoral costumes, carriage and driver, and interaction through sight and gesture between Europa and her companions. Rembrandt's visualization of Ovid's words led him to render the scene with consideration for the action unfolding in time:

"When Europa the king's daughter saw this beautiful bull, so nearby, she held fresh grasses up to his mouth. Upon this, Jupiter rejoiced to himself, and truly hoped that gradually he would have his desires fulfilled. He kissed her hands, and wished for much more. Now he delighted her, now he rolled in the sand, now in the grass, and finally, becoming a little bolder, her also gave her his chest to touch. When she saw that he was so gentle and friendly, she became emboldened, and sat upon his back. Then Jupiter went with his royal foot into the water, and then further, and finally he swam away with his prize.

Europa, seeing that she was already so far from the shore, began to be very frightened, and in order to sit more securely, she grabbed his horn with one hand, and with the other, she held tightly onto his back; thus she was carried away by her unknown lover with her clothes [fluttering] in the wind as if they were sails."

Ovid's text emphasized the deliberate pace and measured progress of Jupiter's advances toward the maiden. Just as Ovid described in words how Jupiter calculated to win Europa's trust, Rembrandt rendered in paint the bull's subtle grin and princess' growing fear. In his characterization of the bull, Rembrandt followed the text: "… his color was white as snow, he had a beautiful thick neck, from which hung a shapely dewlap, beautiful small and brilliant horns, his forehead was without wrinkles, his eyes friendly and charming."

Rembrandt's Jupiter embodies deceit and playfulness, for as he escapes into the sea he averts his head as if avoiding the viewer's gaze. Rembrandt infused a poignancy into the expressions of Europa and her companions that is not evident in any of the printed versions. Another passage from the *Metamorphoses* amplified the dismay and growing alarm of Europa and the companions, woven into the tapestry of Arachne: "Arachne showed how Jupiter, in the form of a bull, carried Europa away, the bull and the river were so well pictured after life that they could not be improved upon;… Europa looked back at the land, calling upon her companions for help, and she lifted her feet out of the water so that they would not get wet."

The graduated responses of the companions and the carriage driver reflect the distance between them and the swiftly moving Europa; those nearer the shore are more aware of Europa's plight and therefore more alarmed, while those further away are just beginning to realize what has happened. The progression of the action as a linear text, unfolding in time, unifies all of the characters.

The canvas *Diana and Actaeon with Callisto and Nymphs* combines in a single frame two episodes distinct in text and time. Diana is the pivotal and supreme figure in both narratives. Rembrandt's Diana focuses upon Actaeon, and many of the nymphs in her entourage focus upon Callisto. In this way, there is a balance of activity directed toward the two hapless victims. In Ovid's text and the many illustrated *Metamorphoses,* the two episodes are considerably separated and occur in different books. However, some artists appropriately associated these scenes. Titian famously paired them in his series for Philip II; although only the *Callisto* was engraved by Cornelis Cort under Titian's direction, the *Actaeon* was anonymously engraved as a pendant to it. In small printed cycles of myths, the two scenes are implicitly paired by Crispijn de Passe I (after drawings by George Behm) and Antonio Tempesta. If Rembrandt was the singular artist who combined both episodes in one frame, he was not alone in pairing them; he merely took the established pendant nature of the two scenes one step further.

Concise Bibliography

Alpers, Svetlana. *Rembrandt's Enterprise: the Studio and the Market.* Chicago: University of Chicago Press, 1988.

Bell, Malcolm. *The Drawings of Rembrandt van Rhijn.* New York: Charles Scribner's Sons, 1908.

Cundall, Joseph, ed. *The Life and Genius of Rembrandt.* London: Bell and Daldy, 1867.

Du Fresnoy, Charles-Alphonse. *The Art of Painting.* Trans. John Dryden. London: Bernard Lintott, 1716.

Focillon, Henri. *Rembrandt: Paintings, Drawings, and Etchings.* London: Phaidon, 1961.

Golahny, Amy. *Rembrandt's Reading: the Artist's Bookshelf of Ancient Poetry and History.* Amsterdam: Amsterdam University Press, 2003.

Lafarge, John. *Great Masters.* New York: McClure, Phillips & Co., 1903.

Morgan, J. Pierpont, and J. N. Laurvik. *Catalogue of the Loan Exhibition of Drawings & Etchings by Rembrandt from the J. Pierpont Morgan Collection.* San Francisco: San Francisco Art Association, 1920.

Nieuwenhuys, C. J. *A Review of the Lives and Works of Some of the Most Eminent Painters.* London: Henry Hooper, 1834.

Scallen, Catherine B. *Rembrandt, Reputation, and the Practice of Connoisseurship.* Amsterdam: Amsterdam University Press, 2004.

Schama, Simon. *Rembrandt's Eyes.* New York, Knopf, 2001.

Simmel, Georg. *Rembrandt: an Essay in the Philosophy of Art,* Trans. Alan Scott and Helmut Staubmann. New York: Taylor & Francis Group, 2005.

Van De Wetering, Ernst. *Rembrandt: the Painter at Work.* Berkeley: University of California Press, 2000.